INSIDE LOOKING OUT

INSIDE LOOKING OUT

The Life and Art of Gina Knee

Sharyn R. Udall

Texas Tech University Press

This book was set in Palatino and printed on acid-free paper that meets
the guidelines for permanence and durability of the Committee on Pro-
duction Guidelines for Book Longevity of the Council on Library Re-
sources.

Printed in the United States of America

Library of Congress Cataloging-in-Publication Data

Udall, Sharyn Rohlfsen.
 Inside looking out : the life and art of Gina Knee / Sharyn R.
Udall.
 p. cm.
 Includes bibliographical references and index.
 ISBN 0-89672-336-4 (cloth)
 1. Knee, Gina, 1898-1982. 2. Painters—United States—Biography.
I. Title.
ND237.K592U32 1994
759.13—dc20
 [B] 94-16030
 CIP

94 95 96 97 98 99 00 01 02 / 9 8 7 6 5 4 3 2 1

Texas Tech University Press
Lubbock, Texas 79409-1037 USA
1-800-832-4042

CONTENTS

For Dana, who taught me about courage, survival, and healing

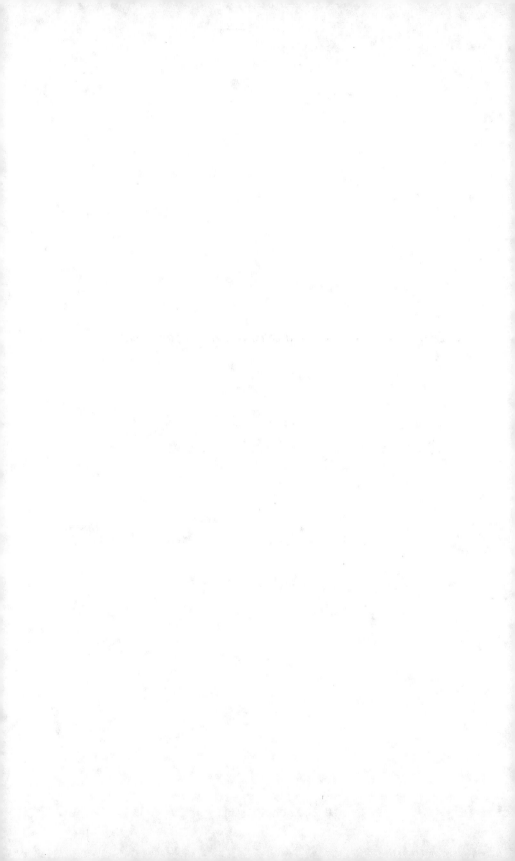

ACKNOWLEDGMENTS

I wish to acknowledge the following persons and organizations for their help with this project. Special thanks are due Sallie Bingham, who provided a generous grant for the color plates. Miani Johnson has allowed me to reproduce photographs of Gina Knee's work from the files of the Willard Gallery and has graciously allowed quotations from the correspondence of her mother, Marian Willard, to Gina Knee. Alexander Brook, Jr., has given permission to quote from Gina Knee's letters.

Individuals who have provided information, advice, and encouragement are Suzan Campbell, Dorothy Chauvenet, Patricia Coughlan, Elizabeth S. Daugherty, Virginia Hunter Ewing, Lou Garbus, Beverly Grossman, Lucia Hale, M. L. Harris, Helen A. Harrison, Calla Hay, Beatrice Johnson, Buffie Johnson, Josephine Little, Helen and Anton V. Long, Toby Moss, Trudy Osborne, Nat Owings, Cynthia Rogers, Lois Rudnick, Naomi Sawelson-Gorse, Donna Bear Scott, Linda Sherry, Eloise Spaeth, Nancy Thompson Taylor, Eugene Thaw, Steve Turner, and Enez Whipple.

I also extend my thanks to Elizabeth Cunningham, the Anschutz Collection; Tiska Blankenship, associate curator, Jonson Gallery, University of New Mexico; and Teresa Hayes Ebie,

Roswell Museum and Art Center. I received valuable help from staff members at the following institutions: Houghton Library, Harvard University; Beinecke Rare Book and Manuscript Library, Yale University; Harry Ransom Humanities Research Center, University of Texas at Austin; Schick Art Gallery, Skidmore College; the Phillips Collection, Washington, D. C.; the Newark Museum; the Newport Harbor Art Museum; and the Guild Hall, East Hampton, New York.

I would also like to express my appreciation to Judith Keeling, my acquiring editor at Texas Tech University Press, for her belief that Gina Knee's art and life deserve an audience.

Finally, my thanks go to my family, who smile, nod approvingly, and think all my projects important.

INTRODUCTION

A major challenge for art historians today is to recon-
struct the discourse of art history to include the experience of
women. Still absent from the canon of art history are the
works of countless women who have labored in near anonym-
ity or who, like Gina Knee, have operated on the margins of
the art world. The discipline has been slow to place the work
of talented women on equal footing with their better-known
male contemporaries. And, until recently, it has been persist-
ent in dismissing the artistic production of women working
within traditional "women's media" as secondary to the
"high" art made by men. Highly visible public careers of suc-
cessful male artists have been relatively easy to document. It
is the achievement of women, whose work has often remained
tangled in the complex web of their personal lives, that has
been difficult to isolate and measure.

But there are encouraging signs. In the last twenty years,
with the publication of dozens of monographs, catalogs, and
surveys of women artists, strides have been taken to recuper-
ate these "lost" artmakers. Of help are an emerging focus on
art as the product of a culture and the recent willingness to in-
corporate the work of social historians into the discipline.

Nothing we do now can change the historical facts of women's lives in the past. The task at hand is to examine lives and artistic production within the context of the time and circumstances in which they occurred. At any historical moment, including our own, an interplay of processes and relationships mediates both the production and the critical evaluation of art. These structures include family, education, patronage, and historical events, as well as the ideologies and codes of the art world. To render an accurate account of an artist's life and work is to take on the slippery, complex critique of this vast system.

The point is not to argue for a woman's native "genius" or for her posthumous elevation to the status of "great artist." This would only reinforce the longstanding "key monuments" or paradigmatic approach to structuring art history. If we, along with scholars such as Linda Nochlin and an increasing number of others, reject the Romantic notions of greatness and genius, we also can reject a closed, exclusively male artistic preserve from which women have long been barred. How, feminist historians are asking, could women be admitted to the category of "great artists" when (especially before the twentieth century) their artistic aspirations usually were denied by social and educational restrictions? Of course, there have always been the exceptions—women such as Sofonisba Anguissola, Artemisia Gentileschi, Judith Leyster, and Mary Cassatt, who received recognition from their contemporaries. Their stories reveal, however, that they often could negotiate the obstacles of the art world because an accident of birth had placed them within an artist's family or with a set of parents unusually encouraging of the education of daughters. In other cases, they simply renounced typical women's roles in society, sacrificing home and family to devote themselves unstintingly to their art. These are the historical exceptions who prove the rule that the categories of artists and women have long remained discrete.

But as women gained access to art academies, life drawing classes, and wider exhibition opportunities, the quality and quantity of their artistic activity increased. As options expanded beyond the either/or choice of being an artist or a woman, women artists challenged once-stifling inherited powerlessness to exercise control in the creative arena of their lives. Yet too often the choice to become an artist still involved sacrifice, isolation, or a freedom that was largely illusory; too often it was, in Myra Jehlen's words, "not actual independence but action despite dependence."[1]

The conditions surrounding a woman's decision to make art, then, are vital to an understanding of it. Much can be learned in this kind of analysis. It allows us to understand, for example, the weight of societal expectations women must carry—expectations that they have often been unable or unwilling to deny. Sometimes it has taken the actions of others to propel a woman into the public domain. Her ability to act in that domain, according to Jehlen, determines her right to a story of her own.[2]

A story of one's own, a room of one's own, an art of one's own. How important is it that one is a woman? Do women make art that is discernibly different from that of men? Can one identify such differences without falling into an essentialist trap? It would be all too easy to succumb to what feminist art historian Griselda Pollock has cautioned against: "the embrace of the feminine stereotype which homogenizes women's work."[3] Female stereotypes are as dangerous as male stereotypes; they limit and circumscribe the possibilities of human behavior. A balanced model, such as that proposed by Elaine Showalter, "incorporates ideas about women's body, language, and psyche but interprets them in relation to the social contexts in which they occur."[4] Or, to state the goal in Nancy K. Miller's terms, the feminist task is "to articulate a self-consciousness about women's identity both as inherited cultural fact and as a process of social construction."[5]

Chosen themes in literature or art, especially when repeated, can reveal something about the artist's self as constructed in relation to social, ideological, and psychological structures. While carefully avoiding stereotypes, we can nonetheless see in the choice and rendering of certain subjects by artists (men or women) how they situate themselves within their own space, explore connections to the earth, and follow mythic paths whose origins lie in the ancient past.

Psychobiographical readings of an artist's work are always risky, but when an artist such as Gina Knee persistently invests her work with clues to her personal state of mind and to a larger worldview, the spectator and the biographer close windows of potential understanding by ignoring them. And in many of Knee's paintings the note of gendered experience resounds clearly; we glimpse her visual responses to the condition and experience of being female. Her paintings are a map of the territory available to her and explored by her as a woman, as a growing artist, and as a whole person. Like all good art, they are at once personal and universal in their scope.

Growth and change are the bywords of Gina Knee's art, for she was a woman born into one world yet drawn to others. Deeply rooted in the nineteenth century, her family and education dictated a life of genteel ease. The daughter of William T. Schnaufer and Ellen Baxter Schnaufer, she was born Virginia Schnaufer on October 31, 1898, in Marietta, Ohio.[6] Her German forebears had immigrated first to Maryland, then to Ohio, where they prospered in oil exploration and lumber businesses. On this foundation the family grew, retaining a strong work ethic and respect for tradition. They spread into neighboring counties and states, with Virginia's family settling in Lexington, Kentucky.

Virginia Schnaufer was brought up to function as her well-to-do family had done, setting family and social obligations above the pursuit of self. Art was not considered a serious activity in the Schnaufer family, though Virginia responded early

4

and often to the visual stimuli in her world. She recalled, "As a child and into my teens, I always painted something—from paper dolls to attempts at pictures of my friends or family."[7]

Women were neither expected nor encouraged to develop their talents beyond the amateur level. They would not, after all, have careers of their own. Instead, the business at hand was preparation for assuming the expected roles of wife and mother. A genteel upbringing in the 1910s was designed to prepare young women for the conventional "marriage plot" so prevalent in literature: In exchange for setting a man a the center of her life, a woman earned, in Carolyn Heilbrun's words, "safety and closure, which have always been held out to women as the ideals of female destiny [but] are not places of adventure, experience or life."[8]

Virginia Schnaufer's marriage plot was enacted early. As a young woman she married Goodlow Macdowell, with whom she pursued an active, genteel life of parties and polo. The marriage lasted ten years, ending with Virginia's abrupt flight from husband and home, leaving even her clothes behind. The details of the breakup are sketchy, because she seldom talked about these years in later life. Divorce was, after all, still scandalous around 1930. In conservative families, people who divorced were often viewed with suspicion or as self-indulgent. Family relationships grew strained; young divorcees were vaguely branded as "fallen."

Paradoxically, it was such a "fall" that permitted Virginia Schnaufer the life she could not have chosen for herself. Given the weight of society's expectations, she could scarcely have imagined for herself the bohemian life of an artist. It was only with her unexpected return to the status of single woman that she began to look back on her previous existence as a life lived at second hand, fulfilling the expectations of others.

Such dissatisfactions call to mind another woman born into a similar situation whom Virginia would meet years later in New Mexico (by which time she was known as Gina Knee).[9]

Mabel Dodge Luhan, born Mabel Ganson to a wealthy Buffalo family in 1879, was a prototype of the restless, striving American rebel, a self-determining New Woman whose audacity placed her at the storm center of avant garde art, politics, and literature for decades.

Both Luhan and Schnaufer would find their best-loved homes in New Mexico—Luhan for nearly half a century, Schnaufer for only a dozen or so years. Each became deeply involved there with the arts community, Luhan as hostess, social activist, and memoirist, Schnaufer as hostess, playwright, and painter. Despite these similarities, however, the two women led markedly different lives. Though they shared many mutual friends in New Mexico, their temperaments were so divergent that they could never become close friends. Mabel was extremely conscious, even jealous, of her own position as social arbiter. She invited celebrated guests—painters, writers, musicians—from the East to visit her Taos compound. There she kept a close eye on their work, entertained them lavishly, and often meddled in their lives. Intelligent, outspoken, mercurial, Mabel kept her circle in a state of continual ferment.

Gina Schnaufer Knee, in contrast, was a less assertive, less tumultuous presence. She brought people together, not—as Mabel sometimes did—to watch the sparks fly, but for the pleasure of having them know one another. Friends recall her ability to make her partner in conversation the object of her full, fixed attention, as if that person's views were of central and profound importance.

Two very different women—one who actively sought control and power, one who would have preferred a world without evident power or control. Despite their differences, the lives of Mabel Dodge Luhan and Gina Schnaufer Knee had one thing more in common: they both married repeatedly. Luhan had four husbands, Knee three. Luhan married and divorced husbands as decisively as she reinvented her life, over and over.[10]

Gina Knee's marriages and divorces also marked clearly defined beginnings and endings in her life. But, unlike Luhan, her life's changes sometimes were involuntary; she did not initiate each of her divorces, and she was more willing than Luhan to maintain an unhappy marriage for its own sake. She wanted the stability (and love, when possible) that marriage provided, but she also needed the satisfaction of individual achievement in the public world. Both she and Luhan vacillated, then, in their attempts to find a self of their own making. They had the independent means to carry out their own choices, but they seemed to define a major portion of their identity through intimate relationships with men. Each was, basically, a male-identified woman—the kind of woman Patricia Spacks has described as having a sense of vicarious reality, "unable fully to accept herself . . . unable fully to exist as a separate self."[11]

Luhan's biographer, Lois Palken Rudnick, has cited as "the outstanding fact of Mabel's life . . . that she never found a clear and coherent direction for herself" because of her belief "that women were dependent on men to realize their destinies."[12] In this belief Luhan and Knee were no different from the majority of their female contemporaries. Relying on a man to complete one's identity was, and is, only too common. But in the cases of Luhan and Knee, women of significant accomplishments, the frequent tension created by their simultaneous impulses to defer and to achieve sets up an always interesting, often revealing narrative. Painful and halting as their choices may have been, they textured the fabric of lives.

Unlike Luhan, who assiduously studied and recorded her own reactions to people and events, Knee did not engage in such public reflection. Her tendency, for example, when a marriage ended, was to set the pain behind her and move on to a new place. In new homes she seldom spoke to those around her of the past, nor did she accumulate quantities of memorabilia that would now shed light on early years. She

kept no diaries or artistic journals; she left no notes and few letters. And it would have been out of character for her to produce an aesthetic position paper. When requested to do so for exhibitions or for entries in *Who's Who in American Art*, she furnished bare accounts of her artistic activity. True, there are still memories in the minds of surviving friends and family, letters that chanced to be kept by others and, fortunately, the public documents of her life in art. From all of these we can catch glimpses—fragments of the passions, doubt, discipline, virtues, quarrels, secrets, bitterness, guilt, resilience, wit,and intelligence that belonged to the whole person.

Any biographer must form a life from what remains. But much has been lost, and we can only wonder how much of the story is missing or distorted due to faulty memories, lost records, or undisclosed information. The fact that she never had children of her own (though she badly wanted them) and acquired grown stepchildren only at the age of forty-seven also lessened the likelihood that memorabilia would be preserved. After her death her papers became scattered or merged with those of her third husband, Alexander Brook. She adopted her stepchildren so that they could inherit from her, but they never inquired deeply into her past life, and Gina Knee seemed content to dwell in the present.

In the conventional marriage plot, the lack of progeny in a woman's life translates as unfulfillment, and there is evidence that Gina Knee felt that lack acutely at times. Nonetheless, the very existence of children would have fortified the demand that they and the marriage itself occupy the center of a woman's life, especially sixty years ago. Without them, there was space at the center of Gina Knee's life for pursuing a talent, for finding a vocation, for transferring expectations from others to herself. "Most of us women, I think," writes Carolyn Heilbrun, "transform our need to be loved into a need to love, expecting, therefore of men and children, more than they, caught in their own lives, can give us."[13]

Life gave Gina Knee, whether by accident or through her choices, an alternative: She found a "quest plot" to pursue, one that allowed her to grow and develop as a person and as an artist. She loved well, faced her share of disappointments, looked for beauty in pain, and loved again. The experiences life handed her are there in her art, but so are her choices, her physical surroundings, and the artistic stimulation she found in the work of many other painters.

There, too, is a temperament that allowed her, long before our own ecologically sensitive decade, to reject the authoritarian discourse of mastery over nature dominant in Western civilization for thousands of years. Instead, she explored (and to some extent identified with) the processes of nature: birth, growth, death, decay, rebirth. Blithely innocent of modern feminists' distaste for traditional alignments of women with nature and men with culture, theory, and intellect, Knee gradually learned to trust her own reactions to nature. She used theory when it suited her—to refine her perceptions and to test her vision. But it was in her direct confrontations with nature that she most often found the visual and metaphorical basis for her art. In the landscape and its smallest details, in the way forms exist in space, in the way color conveys mood and meaning, she found material enough for a lifetime of explorations. And since she declined to tell her own story, the paintings remain to speak for her. Perhaps, after all, that is Gina Knee's most revealing and eloquent text.

Notes

1. Myra Jehlen, "Archimedes and the Paradox of Feminist Criticism," in *The Feminist Reader*, ed. Elizabeth Abel and Emily K. Abel (Chicago: University of Chicago Press, 1983), 75.

2. Ibid., 90.

3. Griselda Pollock, quoted in Thalia Gouma-Peterson and Patricia Mathews, "The Feminist Critique of Art History," *Art Bulletin* LXIX, no. 3 (Sept. 1987): 348.

4. Elaine Showalter, "Feminist Criticism in the Wilderness," in *The New Feminist Criticism*, ed. Elaine Showalter (New York: Pantheon, 1985), 259.

5. Nancy K. Miller, *Subject to Change: Reading Feminist Writing* (New York: Columbia University Press, 1988), 129.

6. The small city of Marietta, Ohio, also was the childhood home of one of America's outstanding nineteenth-century women painters, Lilly Martin Spencer (1822–1902). There she was given her first exhibition in 1841, after which she pursued a successful career in Cincinnati and New York. See Robin Bolton-Smith and William H. Truettner, *Lilly Martin Spencer: The Joys of Sentiment* (Washington, D. C.: National Museum of American Art, 1973).

7. Artist's statement, Gina Knee Retrospective Exhibition brochure, Skidmore College and Larcada Gallery, 1973, n.p.

8. Carolyn G. Heilbrun, *Writing a Woman's Life* (New York: Norton, 1988), 20.

9. During the course of her career, the artist first used Virginia or Gina Schnaufer; after her marriage to Ernest Knee, she began to call herself Gina Knee and used that name for the remainder of her professional life. For social purposes she used each of her three husbands' surnames. Except when discussing her earliest life and the works she signed Schnaufer, I will use "Gina Knee" throughout.

10. See Lois Palken Rudnick, *Mabel Dodge Luhan: New Woman, New Worlds* (Albuquerque: University of New Mexico Press, 1984).

11. Patricia Spacks, *The Female Imagination* (New York: Avon, 1975), 289.

12. Rudnick, *Mabel Dodge Luhan*, xii.

13. Heilbrun, *Writing a Woman's Life*, 120–21.

1

THE 1930S: NEW MEXICO

When asked about her decades-long love affair with the Southwest, Gina Knee often replied that she first came to New Mexico because of John Marin. On exhibit at Alfred Stieglitz's New York gallery An American Place in November 1930 were thirty-two Marin watercolors made the previous summer in the Taos region. Virginia Schnaufer, then living in New York, saw the show and was struck by the powerful forms captured with Marin's confident brush: "It was not until 1931, when I went to New Mexico that I started thinking in terms of 'ART.' Maybe it was the great John Marin show in 1930 of that western country that inspired me to try." As America's premier living watercolorist, Marin found that the active skies, tumbling streams, and mountain masses of New Mexico offered fresh challenges for his form-defining style. Around 100 watercolors from two summers (1929 and 1930) confirm the extension of pictorial range he achieved in New Mexico.[1]

The inspiration generated by Marin's New Mexico sojourns was by no means one sided; he left behind as much as he took, perhaps more. Marin became the Pied Piper of New Mexico landscape painting in the 1930s and 1940s; in the work of painters with modernist inclinations, Marinesque motifs appeared for years. Among the artists working in Taos during

Figure 1. Gina Knee with Ward Lockwood, New Mexico, 1930s. Photo, collection of the author.

Marin's visits were the painters Andrew Dasburg and Ward Lockwood, with whom he spent long days painting and trout fishing.[2]

Just a year later it was Lockwood who renewed for Schnaufer the bold landscape innovations Marin's exhibit had imprinted on her mind in New York. Lockwood's own paintings echoed the overtly chaotic, energized space of Marin's, as seen in a comparison of the former's *Summer Landscape, Taos, N.M.*, c. 1930s, with the latter's *Near Santa Fe, New Mexico*, 1929. Thus

it was natural for Gina Schnaufer, newly arrived in New Mexico in 1931, to gravitate for advice and instruction to Marin's younger friend and protégé. Although she later credited Lockwood more as a role model than an artistic influence, it is clear that his style, overlaid with Marin's, strongly impressed the young woman[3] (fig. 1).

Most of Marin's New Mexico watercolors were of landscape subjects, but in 1929 he had painted a few renderings of Indian dances made following visits to Indian ceremonials at the Taos and Santo Domingo pueblos.[4] Set against the backdrop of their multistoried homes, the tight rows of dancers move in solemn, repetitive rhythms established by sonorous drums and chanting. Symbolically, Marin repeats the reverberating beat in broken lines, border fragments, and abrupt changes of visual direction. Anomalous among his landscapes, these few dance paintings, along with his correspondence, reveal that Marin found them compelling.

Perhaps Gina Schnaufer had Marin's 1929 paintings of Indian dances in mind when she began to visit the ceremonials herself. Though less sure of herself than Marin in her portrayals of the colorful, sun-drenched scenes, she nonetheless looked closely at the patterns and movements she witnessed. She also thought carefully about color; a 1933 catalog statement explained that she spent most of her first year in New Mexico "working out a palette suited to the mysterious dark exhortations, the medieval stolidity, of the Indian dances and Penitente rites and processions on which her interest is centered."[5] Two examples from the early 1930s demonstrate her attachment to and subsequent loosening of the motif. *Eagle Dance, Tesuque,* 1932 (fig. 2), is a rather literal presentation of dancers ranged horizontally in receding planes against a landscape background. Two years later she returned to the subject in *Indian Dance (The Eagle Dance),* 1934 (fig. 3), a composition of considerably more complexity and daring. Instead of a complete figure/ground relationship, we see fragments of

Figure 2. Gina Knee, *Eagle Dance Tesuque*, 1932, watercolor on paper, 13½ x 19½ in. Museum of Fine Arts, Museum of New Mexico.

Figure 3 (below). Gina Knee, *Indian Dance (The Eagle Dance)*, 1934, watercolor on paper, 13½ x 19½ in. Bequest of Marion Koogler McNay, McNay Art Museum, San Antonio, Texas.

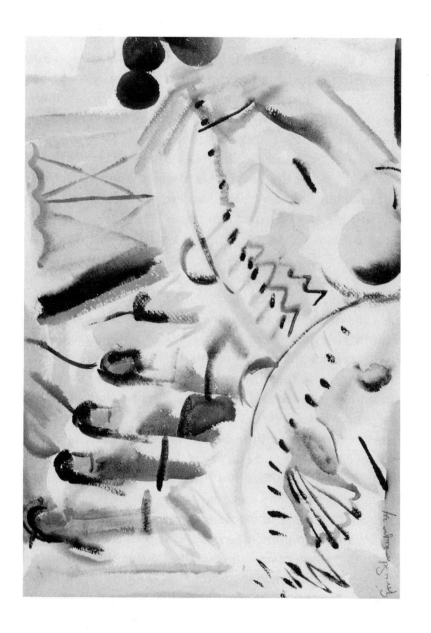

forms arranged without regard for conventional spatial rela-
tionships. Schnaufer has loosened her technique considerably,
using the watercolor medium with confidence and fluidity. A
soft, brushy quality integrates the descending row of back-
ground dancers with the foreground eagle dancers, whose
great arcing wings overlap, dipping rhythmically to the beat
of the dance. Schnaufer has let her sensory experiences merge
into a sea of floating form and color. Unlike better-known por-
trayals of the Eagle Dance by such artists as John Sloan and
Will Shuster, Schnaufer's eliminates detail in favor of the ho-
listic experience of the dance. Like Marin, she affirms Stephane
Mallarmé's well-known protomodernist admonition: "Paint
not the thing, but the effect it produces."[6]

The cohesion of Schnaufer's 1934 composition recalls the
wholeness of Pueblo life, where communal purpose super-
sedes ego and individuation. This integrated Indian view of
life, the antithesis of "Anglo" self-centeredness, fascinated
many newcomers to the Southwest and must have struck the
culturally sensitive young Schnaufer. A few years later she
would reveal in a letter her admiration for the Indian way of
life. A fortunate friend, she wote, possessed "not just artistic
talent but the grace and wisdom to get into the Indian life.
Few people have done it."[7]

Her two versions of the Eagle Dance bespeak vital differ-
ences of conception and execution. In the earlier painting, the
narrative intent overshadows considerations of medium and
technique; Schnaufer's goal was clarity. In the later painting,
however, her choice of medium matters. Watercolor, with its
fluidity and apparent speed, is the appropriate vehicle for
conveying momentary impressions, getting them down be-
fore the patterns dissipate. Schnaufer's growing confidence
in her watercolor technique also invited more adventurous
paint application. Long sweeps with a nearly dry brush de-
scribe thick masses of glossy black hair in the later painting.

Often accompanying the painter on her visits to the Indian ceremonials was a new companion, Ernest Knee. Wintering in Tucson the previous year, she had met the young Canadian, in Arizona to relieve the symptoms of his tuberculosis. Knee was a talented young man, nine years younger but with an already broad range of life experiences. He had been in the Merchant Marine, played piano, managed and cooked at restaurants, studied business administration and, on his own, learned photography. A childhood battle with rheumatic fever and his current struggle with tuberculosis had left his love of life undiminished. Knee was a bright, articulate, and fun-loving companion for the young divorcee from the East. He recalled later that when he met her she had just changed her name from Virginia to Gina, "pronounced with a hard 'G.'"[8]

In the warm Tucson sunshine the two new friends explored the environs of the guest ranch where they stayed. Gina would take her watercolors, Knee his sketchpad. As the weeks passed, they found common interests and pleasure in being together. By May the Tucson weather was becoming hot; Schnaufer invited Knee to drive with her to Santa Fe—to Marin country. She went on to Taos to study with Lockwood, while Knee remained in Santa Fe and pursued his study of photography. Their relationship deepened with Gina's return to Santa Fe, and the two married in 1933.

They moved into the painter Walter Mruk's vacant house on Camino del Monte Sol, in the heart of the town's art activity. Mruk, one of Santa Fe's Cinco Pintores group of painters, had joined his colleagues a decade earlier in building themselves neighboring houses along this colorful street. Though Mruk had left the area and the group officially disbanded, the remaining Cincos were still active and welcomed the new couple into the town's artistic community. Always nearby were potential mentors for her painting and his photography, and the human and landscape subjects were plentiful.

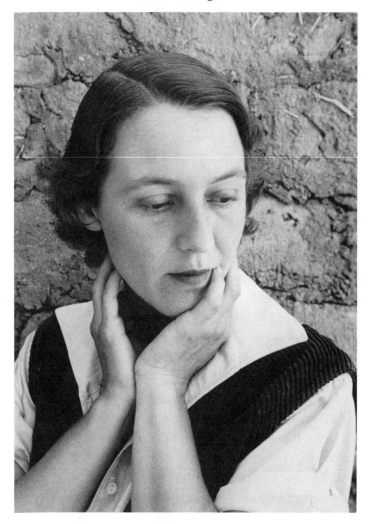

Figure 4. Ernest Knee, *Gina Schnaufer*, 1932. Photo courtesy Eric Knee.

Ernest Knee made a conscious decision to become a professional photographer in New Mexico. He read all about photographic chemistry and set up a primitive darkroom in the bathroom. Using a large-format camera, he took pictures of their new artist friends, the local Fiesta celebration and, later,

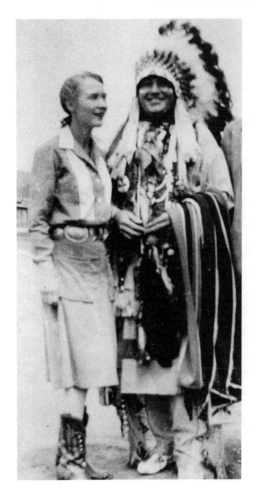

Figure 5. Left: Gina Knee; the figure on the right is unidentified, 1930s. Photographer unknown. Collection of the author.

many northern New Mexico churches. He also made portraits of Schnaufer, who proved a splendid model (fig. 4).

On festive occasions Gina, like many Santa Feans, adopted Southwestern dress: cowgirl boots, riding skirt, and silver concha belt (fig. 5). Over the years, Gina's style of dress became distinctive, combining Eastern urban chic with a certain nonconformist flair that turned heads.

Her Southwestern attire was pictured again by Willard Nash, who painted Gina's portrait during these years (fig. 6). Nash, one of Santa Fe's resident painters and a close friend of

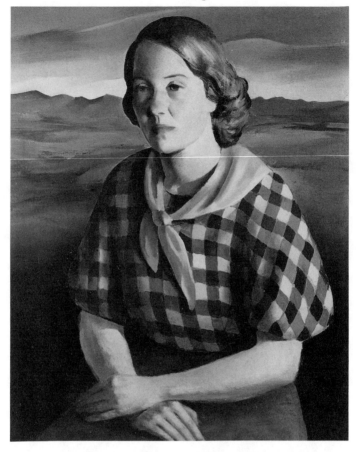

Figure 6. Willard Nash, *Gina Knee [Brook)*, c. 1930s, oil on canvas, 31 x 25 in. Museum of Fine Arts, Museum of New Mexico.

the Knees, captured her blond good looks, but his portrait reveals little of the sitter's character. More decorative than interesting, she has been snagged on the barrier of her own physical attractiveness. More than once Gina's beauty would deflect serious consideration away from her accomplishments. A visiting novelist, reviewing a Santa Fe group show in 1933, praised Gina's watercolor of an Indian dance but then added, "It is too bad that Mrs. Schnaffer [*sic*] will not be in the museum all the time to pour tea. She is a decided asset in person (decoratively speaking) to the show."[9] Undoubtedly the

reviewer's words were well-meant, but they suggest subtly that what Gina Knee did was somehow less important than how she looked.

Gina's adoption of Western dress and her sensitive though still amateurish watercolors of Indian ceremonies mark her attempts to commune with her new environment and neighbors. That she could not do so completely testifies to both her cultural difference and her honesty. She knew that, by birth and upbringing, hers was a world apart. Anglos in the Southwest had long succumbed to fashionable theories of "cultural primitivism"; the wiser among them realized that there is a point on the journey to ethnic intimacy beyond which one cannot go. To her credit, Gina recognized such obstacles and with good grace accepted a certain apartness from the Indian culture. More significantly, she championed the cause of Native American identity in life and in their artistic production. When government-sponsored Indian schools proposed adopting "European-style realistic" painting for their curriculum in 1940, Knee and her friend Margretta Dietrich circulated a strongly worded letter opposing such a change.[10] They urged artists to write government officials protesting the imposition of Euro-American aesthetics on the Native American students.

But Gina could also see the lighter side of cultural encounters. John Sloan, whom Knee and Schnaufer came to know during his annual summer visits to Santa Fe, already had taken aim at the overeager Anglo tourist. Intent on immersing themselves in the Southwest experience, Sloan's tourists crowd into the pueblo dance plazas, threatening to suffocate both themselves and their subjects. Sloan's well-known etchings *Knees and Aborigines* and *Indian Detours* portray such scenes.

Gina, too, could poke fun at Anglo tourists with deadly accuracy; after all, she was a relative newcomer herself. In a number of drawings and watercolors she probed relentlessly at the insensitivity of visitors. In a wash drawing she captioned *My Dear—it's a Fertility Dance!*, 1933 (fig. 7), the words

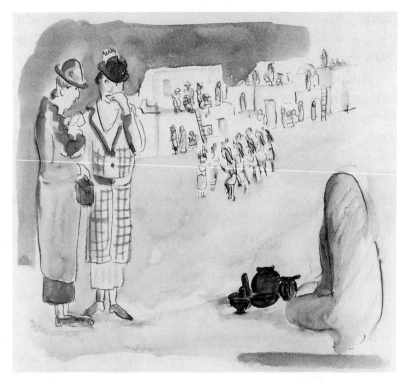

Figure 7. Gina Knee, *My Dear—it's a Fertility Dance!*, 1933, watercolor on paper, 11 1/2 x 8 1/2 in. Museum of Fine Arts, Museum of New Mexico.

of the two embarrassed post-Victorian matrons at the left embody the vast cultural divide between white and native cultures. Though humorously cast by Knee, the scene reminds us vividly of decades-long efforts by a paternalistic United States government to suppress Indian dances as degrading and demoralizing orgies.[11] Knee's amusing drawing belies the artist's recognition of more serious cultural misunderstandings. At the same time, the presence of another seated figure at the right invites a more personal consideration of Knee's intent. With her back to the viewer sits a blanketed Pueblo woman, a few pieces of pottery spread before her on the ground. The presence of such pottery sellers was and is common at the pueblos. But her inclusion in Gina's drawing, one senses, rep-

resents more than mere compositional ballast. Anonymous, silent, watching, the Indian woman is a link to an ancient tradition of women as artmakers whose work confers both communal pride and self-respect. Might Gina have identified a little with this woman, as well as with the discomfited tourists? In Knee's Anglo world, women rarely "made it" as professional artists. They had to choose, it seemed, between being a woman and an artist. Was Gina musing over this personal oxymoron even then?

A few years later Gina satirized tourism again, this time in a play about role reversals. Writing had long been an interest, with several detective stories and other short pieces to her credit. Now she wrote a one-act play she titled *Monkey in the Mirror*. She described the plot:

> A satirical comedy laid in that part of the southwest where the Pueblo Indian is constantly "visited"by a certain well-known type of American tourist. The play reverses this custom and ironically shows how things would be if the Indians were the traveling enthusiasts and the white man the exhibition piece.
>
> The scene is the home of a white man and wife whose son has just returned from boarding school, but their happy reunion scarcely starts before a party of avid Indian sightseers invades their privacy. A Seminole, a Cheyenne princess, a woman from a pueblo and their Indian guide inspect, interpret, and ruthlessly enjoy the curiosities of Paleface life and culture in a fast-moving variety of ridiculously funny scenes. A singing shower-bath ceremony, a demonstration of the golf game, a modern jazz dance in "ceremonial" dress and other comical analogies produce a highly diverting and most unusual comedy.[12]

With the author as director, the play was first performed to an audience of friends at the Canyon Road home of Virginia and Russel Vernon Hunter. It was received with genuine and knowing hilarity. Audience, cast, and playwright, themselves transplanted from other parts of the country, found tourists fair game for ridicule. This time, though, with the tables turned, the Anglos were given a sardonic glimpse of their own awkward attempts to penetrate the secrets of the local culture.

Tourism, then as now, was vital to the economy of Santa Fe. Even the artists, much as they might deprecate the sometimes intrusive visitors, depended for their livelihood on sales to tourists. And they all knew it. Gina's independent means cushioned her against the economic necessity of selling her paintings to tourists, but she recognized, as did her artist friends, that sales were one measure of acceptance for any artist.

Another measure of acceptance was participation in the community's artistic life. Gina had come to the Southwest to start a new life, and she undertook it with great energy. The painter and the photographer were a romantic couple; they wanted to live in an original way, and like many young artists they set about it consciously. Gina's naturally gregarious ways attracted friends easily; the couple became acquainted rapidly with like-minded artists and writers, many newly arrived like themselves. Soon the Knees' home was the scene of frequent parties, with entertainments concocted by the hostess. Virginia Hunter Ewing tells of evenings filled with the laughter of charades, word games, and vibrant conversation— something like a small-town version of New York's Algonquin roundtable. Indeed, the Knees' visitors were as often literary types as artists. Haniel Long, whose poetry and nonfiction included *Atlantides* (1933) and *Interlinear to Cabeza de Baca* (1936), became a close friend, as did poet and playwright Lynn Riggs, best known for his *Green Grow the Lilacs* (1931). Riggs's play *Russet Mantle* was set in Santa Fe; its characters were based on thinly disguised Santa Fe residents and local

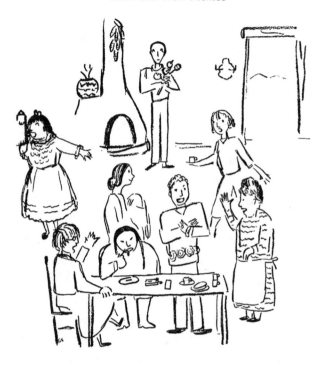

"The sun is overhead, and the earth is underfoot."

Figure 8. Gina Knee, illustration for D. H. Lawrence's unfinished play *Altitude*, from *Laughing Horse* 20 (1938).

"types." Central characters are two genteel ladies from Kentucky who in certain respects strongly resemble the well-bred Gina Schnaufer. *Russet Mantle* was first performed in New York in 1936. Riggs and Long undoubtedly encouraged Gina to write and produce her play *Monkey in the Mirror* during the following year.

Gina also came to know Willard "Spud" Johnson, who edited a gadfly literary quarterly known as *Laughing Horse*. In 1938 she illustrated for that publication an unfinished play by D. H. Lawrence called *Altitude*. Begun by Lawrence in Taos more than ten years earlier, the comedy included among its characters such New Mexico notables as Mabel Dodge Luhan (described as "a determined lady who always knows what she

wants—and gets it"), her husband Tony ("An American Indian philosopher"), writer Mary Austin, Ida Rauh Eastman, and editor Spud Johnson himself. Gina's illustrations for the play are simple line drawings that capture the foibles of each individual character; all are goodnaturedly caricatured in a style at once childlike and incisive (fig. 8). Readers who saw them, according to a contemporary, had no doubt about the identity of any character.[13]

Fun and games. The merriment spilled over into many occasions, and Gina was always ready to add her humor, taste, and talents to them. In 1933 an artists' ball was organized at the La Fonda Hotel by more than fifty members of the painters and sculptors association. The nominal chairman for the event was the venerable painter William Penhallow Henderson, but in fact Gina Knee supervised much of the work, including decorations. She asked everyone to come as an undersea creature and transformed the ballroom into a splendid watery domain. Prizes awarded for winning costumes included her own mermaid attire, complete with green wig.[14] Gina's enthusiasm and skill made the evening a resounding success, and it became an annual event.

What a small town and small world it must have been. Guests came and went, adding to the already lively Santa Fe scene. It had achieved a reputation as an artist's colony second only to that of its smaller northern neighbor, Taos. Older and, by the 1930s, more inbred, the Taos colony continued to attract artists and writers, often at the invitation of Mabel Dodge Luhan, whose cultural hegemony was unquestioned everywhere north of Española. In Santa Fe, things were looser. Closest to Mabel's kind of influence was that of Witter Bynner, poet and author, who with Mary Austin and Alice Corbin Henderson had mobilized and energized the town's artistic life since the twenties. Santa Fe, larger and more accessible than Taos, attracted a wider range of visitors. Hospitable and amusing, the Knees welcomed more than their share. One

who came several times was the celebrated photographer Edward Weston, whom Ernie had met in 1932 through Willard Nash. When the Westons visited Santa Fe on a Guggenheim Fellowship trip in 1937 they stayed with the Knees; Edward used Ernie's darkroom to develop negatives, and together they photographed various sites in northern New Mexico.[15]

Ernie's work was gaining recognition in and out of New Mexico. His photographs were often reproduced in magazines and books, once with Weston's in Mabel Dodge Luhan's *Winter in Taos* (1935). Knee was chosen for a WPA exhibition of American art circulated around the nation. He had become, according to Van Deren Coke, "probably the best resident photographer in New Mexico" during the 1930s.[16]

At the same time his wife longed to achieve her own recognition. She knew she must make a conscious commitment to art. But it was one thing to call oneself an artist in a town of artists, and quite another to rearrange her life's priorities into a list headed by "ART." Gina had been brought up to defer to men, to place her interests after theirs. What's more, she was determined to make this marriage work. Ernie needed her support and her attention. Could she find the time and energy to run a household, keep a close eye on her husband's delicate health, entertain their frequent guests, and still paint—seriously paint?

Gina was already in her mid-thirties when she began to discover a visual language to express what she had to say. When, if not now, would she become determined enough to give her art what it demanded? Would the years ahead allow her to grow? Perhaps it was just such concerns that prompted the Knees to move out of the busy center of town, out of the path of well-meaning friends and away from distractions.

Gina and Ernie found a piece of property in the nearby Tesuque valley. It was just a few miles north of the center of Santa Fe, but secluded enough to promise life a little apart from the busy "Camino." Greener than the rest of Santa Fe Te-

suque was an irrigated agricultural oasis where Hispanics and their Anglo neighbors planted orchards and watched their chile grow. One of Gina's most joyous watercolors reflects the seasonal rituals of nature in Tesuque: *Tesuque Spring Apple Trees*, 1940 (plate 1).[17] The valley offered the Knees a life of tranquil promise; solitary, pastoral, it seemed a place where one could build a quiet life with art at its center. A photograph from this period shows a beautiful, senene Gina in her garden (fig. 9).

Together the Knees designed the perfect house.[18] It would be spacious, with room for Gina's Victorian antiques and the handsome handmade doors crafted by Ernie. Off the kitchen was Ernie's darkroom; on the other side of the house Gina's spacious, high-ceilinged studio was oriented for ideal northern light. This would be her first real studio, as opposed to the odd extra room converted for her painting in previous houses. The studio would be at once a quiet refuge from daily distractions and the site of happy turmoil where she could wrestle with the artistic problems she set herself. There she could enjoy the messiness of ongoing work, then store it all in the ample closets built for that purpose. Having her own studio represented a new kind of freedom for Gina. At the same time it was a kind of statement of serious intent, a promise made by the artist to herself.

The house's covered portals and sunny patios invited the outdoors in, and its low profile married the adobe architecture lovingly to its surroundings. Close by, in season, the *acequia* (irrigation ditch) bubbled quietly. Building materials were local: thick adobe bricks were formed on-site, then dried in the sun. The walls rose in rough courses more than a foot thick. Finally, skilled hands smoothed them with straw-flecked mud plaster. Tree trunks of pine from nearby mountain forests became *vigas* for the ceiling; local craftsmen helped Ernie to carve the wooden lintels, corbels, and doors that lent authenticity to the house.

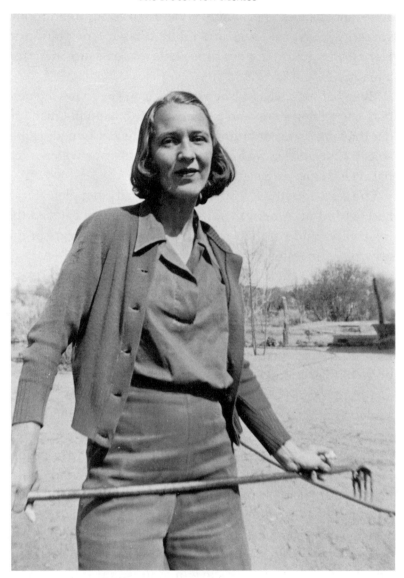

Figure 9. Gina Knee gardening in Tesuque, New Mexico, late 1930s, photographer unknown. Photography collection, Harry Ransom Humanities Research Center, University of Texas at Austin.

Gina had been accustomed to beautiful things; now she surrounded herself again with spaces and objects reflective of her catholic tastes and privileged upbringing. With a sure sense of

style, she installed her family's Victorian furniture in rooms spread with Navajo rugs and modern landscape paintings. Her means and Ernie's building skills made the dream house a reality.

Even before it was finished friends came by to see the new place, to sit in the sun and perhaps enjoy a late-fall lunch under the long ristras of drying red chile. The Lockwoods came; so did Cady Wells, whose modernist landscape watercolors paralleled Gina's own artistic concerns.

Life seemed settled. The house was finally complete, Ernie had become an American citizen, and the couple enjoyed the relative solitude of their rural retreat, scarcely aware of the growing depression ravaging the rest of the country. From all outward signs their happiness was complete. Or nearly so. Gina wanted a child. Her naturally giving, nurturing spirit wanted to extend their circle of love beyond themselves. But they found they were unable to have a child. Moving beyond their disappointment, the Knees made an extraordinary proposal to their friends Virginia and Vernon Hunter: the Hunters' child Kim would become the Knees' adopted son, so that someone could inherit her estate. Although the proposal was never realized, Gina lavished motherly concern on Kim and other children. In December 1941, recalls Virginia Ewing, Gina made young Kim a warm fur coat out of an old one of hers. Other friends' children remember Gina Knee's kind attention: Kevin McKibben, son of Gina's close friend Dorothy McKibben, remembers that during a childhood illness Gina came over to visit and entertain him. Together they wrote stories about animals, stories she would illustrate with amusing drawings.

Despite unfulfilled personal longings, Gina found rewards in her work. With her customary energy and enthusiasm she threw herself into painting. After the initial exploration of Indian themes and subjects, she had turned to landscape. Focusing closely on this area during the thirties and early forties, she

would ultimately find in landscape her own essential vision. The going wasn't easy, but she had chosen a good place to learn and grow. Criticism—constructive and otherwise—was readily available in Santa Fe. So were exhibition opportunities.

As early as 1933 Gina had exhibited at the Museum of Fine Arts, whose long-established "open door" policy brought artists together with an interested public. The early landscapes Gina showed at the museum were timid, traditional, and—not surprisingly—much in the mode of her mentors. As to the first quality, timidity, one can scarcely fault her. Even her hero Marin had approached the formidable New Mexico landscape with caution. Years of experience in many locations didn't ensure instant confidence, even in the renowned Marin, whose 1929 watercolor *Blue Mountains, New Mexico* is firmly anchored in the *given*. Marin was not an isolated case; his experienced contemporaries Marsden Hartley, Andrew Dasburg, Stuart Davis, and Edward Hopper all were initially intimidated by the New Mexico landscape.

Gina Schnaufer's landscape *Pecos Canyon*, 1933 (fig. 10), one of the first she made in New Mexico, is neither surprising nor especially inept. Her subject, a stream flowing towards the viewer through a wooded landscape, is similar to paintings by both Marin and Lockwood. In the lower right corner of her painting strong, angular strokes describe blocky rocks along the stream bank—a lively, Marinesque passage. What bothers the viewer most in her painting, however, is its inconsistency. Just to the left of the foreground rocks is a clump of grass, an awkward device apparently designed to "close" the foreground space but in its delicacy functioning more like a sprig of parsley—all garnish, no substance. The remainder of the painting combines an obviously serious attempt to reproduce an observed scene with some elements frequently seen in Santa Fe painting during those years. One senses echoes from the work of Jozef Bakos, B. J. O. Nordfeldt, or Willard Nash in the assertive hills and trees. (All were Santa Fe residents with modernist

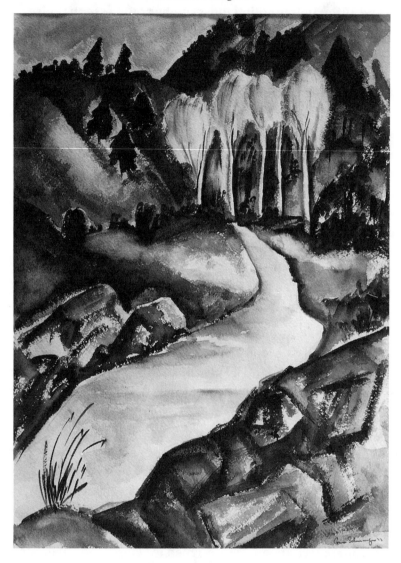

Figure 10. Gina Schnaufer, *Pecos Canyon*, 1933, watercolor on paper. Photo by T. Harmon Parkhurst, courtesy Museum of New Mexico, Neg. No. 73931.

inclinations.) Except for the weak clump of grass, Schnaufer's painting is a competent handling of the subject. For a newcomer to the region and, in fact, to painting itself, she was moving rapidly.

In 1933 Schnaufer joined a newly formed group of artists who called themselves the Rio Grande Painters. For the most part they were men and women she had already come to know. Cady Wells, Charles Barrows, Paul Lantz, James Morris, and McHarg Davenport were the male members. An almost equal complement of women rounded out the group: E. Boyd Van Cleave, Anne Stockton, Eleanor Cowles, and Schnaufer. In common were the group's roots elsewhere; all were fairly new to New Mexico. They secured gallery space in Santa Fe at 129 East Palace Avenue and set into motion an active schedule of local and traveling exhibitions. Gina was elected the group's president in 1934 and served in that capacity at least until 1938. Within the first few months of the group's existence, they issued a "biographical catalogue" in which they explained that the Rio Grande Painters group

> is composed of painters bound together mainly by a preference for the Southwest, both as a place of residence and a perpetual mine of paintable material. No common aesthetic standard or technical similarity exists in their work, hailing as they do from all parts of America and claiming totally different instructors.[19]

Soon the group sent a show touring through the Midwest, where it was generally well received. Another exhibit at the Worcester Art Museum in Massachusetts in October 1934 was picked up by the American Federation of Arts and circulated to museums elsewhere in Massachusetts and Connecticut, Pennsylvania, and Tennessee.

These years in American art, it must be remembered, were the heyday of American Scene regionalist painting. Themes of the authenticity and diversity of American life were being sought and celebrated everywhere in art. Despite their disavowal of any "regional" homogeneity, the Rio Grande Painters were cast by several critics in a loose regional grouping. As

one wrote, "Perhaps the regionalism of this group, as seen in the light of Mr. [Lewis] Mumford's criteria may lack the qualities he finds at [a regionalist show in] Dartmouth. But perhaps, too, we may see in the group the beginnings of the real thing.[20]

While their paintings toured other parts of the country, members of the Rio Grande Painters continued to exhibit individually at home. Most were included in the major shows at the Museum of Fine Arts in Santa Fe, especially in the annual exhibit of painters and sculptors of the Southwest, better known as the Fiesta show. Held in September each year, this big, nonjuried show was an informal summation of art in the area. Schnaufer had three watercolors in the 1934 show. Her paintings the following year were singled out for comment in a review by Rio Grande colleague E. Boyd: "Gina Schnaufer seems to be going through a period, or is it an outbreak of cutting away old rigging and working with all new gear. This will undoubtedly lead to something ot interest, but meanwhile we are left a trifle disappointed."[21]

One wonders if the paintings Boyd found disappointing were like *Sun, Wind and Stars* (fig. 11), a 1935 watercolor that does indeed represent a departure from earlier landscapes by Gina Schnaufer, who began about this time to sign herself Gina Knee. Loosened and simplified, it reformulates landscape questions asked by Marin in 1930 in such paintings as *The Taos Mountain Storm* (1930). Here is the earliest example of real freedom in Knee's watercolor technique—the point at which, she remarked years later, "I got to be abstract without knowing it."[22]

Of course, such breakthrough paintings are not products of an immaculate conception. Boyd saw in Knee's 1935 work a struggle, a labor to bring forth something new. Glimmers of that nascent freedom can also be seen in a painting Schnaufer made during a trip east the same year. *Near Pittsburgh*, 1935 (plate 2), subjects the industrial energy of the teeming steel

city to her new surety of touch. Sweeping veils of wet color contrast effectively with drier strokes and deft linear accents. The year 1935, clearly, was one of great forward leaps in Knee's technique and in her artistic vision.

Boosting her confidence were increased opportunities to exhibit. Starting in 1934 she entered her work in the yearly international exhibitions of watercolors at the Art Institute of Chicago, continuing that practice nearly every year through the 1940s. She joined the California Watercolor Society and participated in their group shows from 1935 to 1940, winning a second prize there in 1938.

A trip to the West Coast in the spring of 1936 produced *Swallows Returning to Capistrano,* a semi-abstract painting in deep browns and grays she liked well enough to keep the remainder of her life. (She would revisit the subject while living in California in the 1940s.) Exhibited in New Mexico, where art audiences and critics largely were conservative, Knee's watercolors continued to elicit mixed reactions. Her entry in the 1936 Fiesta show was described unenthusiastically as "an abstraction in dull colors" (perhaps similar to the Capistrano painting).[23]

Landscape continued to be her preferred subject, but she frequently forayed into other areas. Knee not only was sensitive to her physical environment but felt keenly the spiritual interaction between the landscape and the people. She had first seen this delicate harmony in the lives of the Pueblo people. Now she began to observe the lives of the Hispanic residents of northern New Mexico, especially in the small villages where a simple, traditional Catholic faith was as much a part of life as the sun and rain. When she exhibited a now-unidentified figure group in a Rio Grande Painters show, a local reviewer noted:

> Gina Schnaufer feels the symbol of the cross looming large in the lives of the people at Chu-

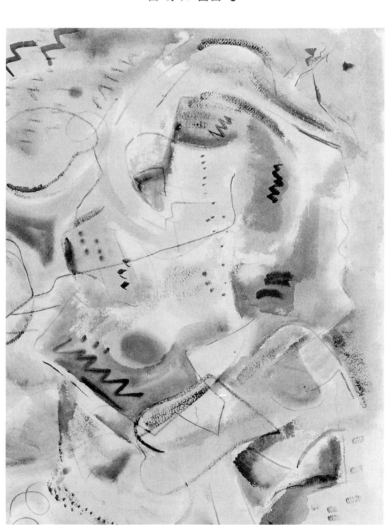

Figure 11. Gina Knee, *Sun, Wind and Stars*, c. 1935, watercolor on paper. University of New Mexico Art Museum, gift of the artist.

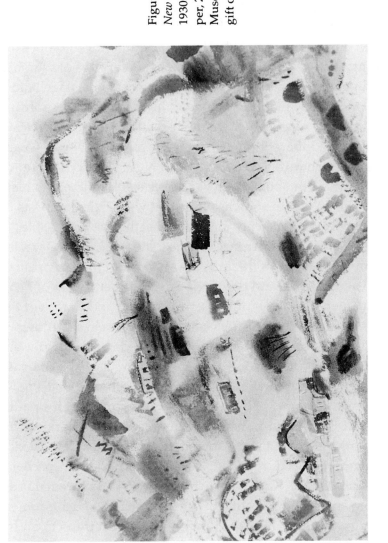

Figure 12. Gina Knee, *New Mexico Village* c. mid-1930s, watercolor on paper, 22 x 28 in. Roswell Museum and Art Center, gift of the artist.

padero and paints it in that proportion. Beside it are a man and woman, with child held tenderly in the woman's shawled arms. Figures moved toward the little church, adobe homes are indicated, the simple, fundamental values of Chupadero.[24]

Though not a religious person herself, Knee (along with many other artists working in New Mexico before and since) was intrigued by spiritual practices that seemed primitive in their fervor and secrecy. These were the rites of the Penitentes, a self-sufficient group of lay Hispanic Catholics who since the eighteenth-century have celebrated secret rites of worship and penance, including Holy Week processions, flagellation, and mock crucifixions. Somehow, the survival of these arcane and archaic practices in twentieth-century New Mexico testified to the inherent power of the place. Even world-weary eastern urbanites could sense it; New York critic Henry McBride, writing of Georgia O'Keeffe's enthrallment to New Mexico, noted "the Spanish idea that where life manifests itself in greatest ebullience there too is death most formidable."[25]

One of Knee's references to the Penitentes is a watercolor from the mid-1930s (plate 3) in which four crosses appear—two vertical ones and two angled over the bent backs of Penitente men in solemn procession. The size and shapes of the crosses, so like their bearers, make them seem like shadows or consciences of the Penitentes. The canted, ninety-degree angles of men and crosses are repeated precisely in the pass through the mountains beyond. Nature echoes and acknowledges the import of events below. It is a mysterious painting—respectful, stiff, and sober. Compared with the powerful paintings of the subject rendered by some of her New Mexico contemporaries (Lockwood, Nordfeldt, Ernest Blumenschein, Howard Cook), Knee's is far from successful. It remains an awkward, probing gesture by an artist unsure of her technical means, unclear about her own private reactions to an intensely spiritual subject. Yet for all its fumbling, we sense here

an artist determined to find her way, to risk failure as a step towards growth.

Knee's openness to change was in part a factor of her inexperience. Unlike many New Mexico painters, she did not bring with her much "artistic baggage" from elsewhere. What she learned about art she learned in New Mexico, and she knew she was just beginning. Beyond that, though, was the fact that she was a woman, less ready to quantify, objectify, and judge than many of her male colleagues. Instead of separating her life strictly into the categories of public and private, of woman and artist, she already knew how to integrate the various parts of herself. Like countless women everywhere, she had learned of necessity to embrace the whole of life. All of it was mixed up together. Painting, loving, managing a household, maintaining close friendships—all these were part of her special skills and training as a woman. Though these skills would at times produce devastating demands on her, she never closed her eyes to the changing possibilities life and art presented.

In many ways, Gina Knee's life in New Mexico was lived on the edge of discovery. Granted, much of the art produced in the state was only moderately inventive; even less of it was deeply expressive. Still, if ever there was a place where such art could be made, should be made, it might be New Mexico. Never a neutral environment, New Mexico has an art history that must be recorded as often in the bitter disappointments it has produced as in the successes it has bred. Looming over the unforgiving landscape was always the active pull of the spiritual, whether formalized in Penitente ritual or in the chthonic marriage of earth and dancers in Pueblo rites. Artists could never leave it alone, never, it seemed, have their fill.

To Gina Knee it was a sea of patterns, faces, colors—impressions impossible to forget. Thirty years after she left the state it was all still fresh:

Through the thirties and up to 1945, I painted everything I could see: Indian dances, the Spanish Americans—the deserts and mountains—but after a few years of exploring what I saw objectively, I started painting more abstractly, trying to express in the forms their spirit, or sound, or smell—a more complete picture—a sensual statement—as important as the forms.[26]

Gina Knee was maturing in her effort to express this "more complete picture" of the world of forms. Though she kept nature always before her, she was increasingly drawn to its more subtle emanations. Spirit, sound, and smell—difficult enough to describe in words if one were a poet; how could they be expressed in visual terms? Perhaps it required an analogical approach to nature, with emphasis shifted from the forms themselves to the qualities of interplay, movement, and change among them. One would have to go into the places where forms are born, where the constant *becoming* in nature occurs. Perhaps within these tiny interstices one could find the energy that held the whole pulsating mass together. Knee was sure by now that objective painting was behind her. A new artistic identity would eventually emerge, and with each new painting she glimpsed its growing vocabulary of abstract forms.

From John Marin she had learned about spontaneity. And she knew that in the fluidity of watercolor she could best suggest the mutability that is the life and force of nature. It was a kind of synesthesia, this transfer of energy from nature to her brush, and she meant to catch it on paper. To do that, she began to feel that she had to *enter* her paintings in a new way, to be there in the midst of the sounds, smells, and spirit.

Almost without realizing it, she began to abandon the traditional Renaissance "window" picture space. Documenting foreground, middle, and background space in a neatly formulated perspectival system became too much like a teleological

exercise. Too much spontaneity was lost in the tedium of organizing the whole thing. Besides, she wasn't sure she wanted that kind of control over her paintings. The enterprise of perspective suited the representation of human-constructed space, of towns, for which the fifteenth-century Florentines first used it. Moreover, the imposition of perspective on a scene speaks of a male-ordered civilization of the Renaissance type. As Kenneth Clark has written, "The belief that one could represent a man in a real setting and calculate his position and arrange figures in a demonstrably harmonious order, expressed symbolically a new idea about man's place in the scheme of things and man's control over his own destiny."[27]

Gina's paintings were not about control, and she was not bound by an art-school training that demanded perspectival ordering. The first of its two traditional uses—to render the precise position of a figure in space—was not high on her list of artistic priorities. The second—to increase awareness of space—she wanted to accomplish more innovatively than with perspective. Neither could she embrace the hierarchy implicit in strict perspectival ordering. She seldom wanted to rank elements in her paintings in order of importance. That, too, was a male propensity.

Instead, her paintings substituted a sort of natural chaos for a rigid internal order. For Gina it was an advantageous trade-off. In truth, she lacked formal training in perspective, except for a smattering picked up during her few weeks at the Art Students League in New York and whatever offhand appearance it made in Lockwood's informal teaching. Even the great god Marin made his spatial treatment seem effortless, although his architectural training left traces of an architectonic order.

In sum, Gina's disregard of traditional figure/ground organization was arrived at both through inclination and default. What she had never really mastered was that much easier to discard. So she never bothered much about it, concen-

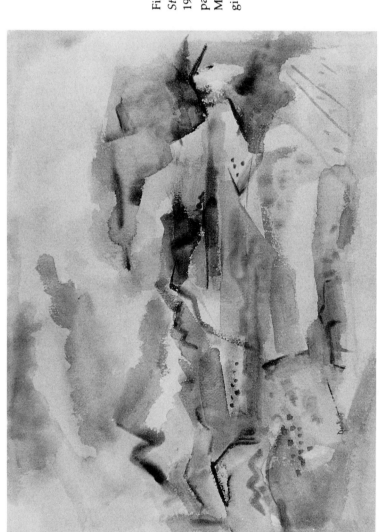

Figure 13. Gina Knee, *Storm at Otowi*, c. mid-1930s, watercolor on paper, 18 x 23 in. Roswell Museum and Art Center, gift of Paul Horgan.

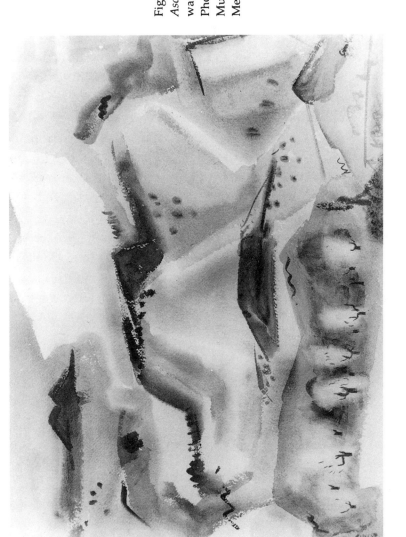

Figure 14. Gina Knee, *Ascending Cloud,* 1938, watercolor on paper. Photo courtesy Museum of New Mexico, Neg. No. 20002.

trating instead on a relationship of forms based on harmonies of pattern, color, and emotional qualities. Even when, as in *New Mexico Village* (fig. 12), she painted a town—a subject dear to the hearts of Florentine pioneers of perspective in the fifteenth century—she allowed it to meander all over the paper. Of course, New Mexico villages are like that. Organic, without formal planning, they adhere to no particular order. And they change. Old adobe buildings gradually melt back into the earth, replaced by new ones. Birth and death are close neighbors in New Mexico architecture, as in its religion. But, *New Mexico Village* is not about a town as such. Its content is as much the hills, arroyos, and air as the tiny buildings, which cling to the heaving earth like houses on a Monopoly board. The composition becomes a loose weaving on a time loom.

Time is an element in several other Knee paintings from the late 1930s. In *Storm at Otowi* (fig. 13), the sky is all action, involving and invading the land forms below. *Ascending Cloud*, 1938 (fig. 14), evokes a gentler mood from nature.[28] No heavy rainclouds obscure the sculpted hills, which loom over the barely suggested presence of humanity in the valley orchard below. When *Ascending Cloud* was exhibited in the 1938 Fiesta show at the Santa Fe museum it received a favorable review in the museum publication from Alfred Morang, a local painter and critic who became an admirer of Knee's work:

> Gina Knee achieves that balance between the real and the imagined that is the keynote of all successful abstraction. Her washes of vibrant color sing with inner life. One may say Marin has influenced her, but his influence has been a good one. She stands in the front rank of women painters because she never allows charm to overcome more solid values of design and color strength.[29]

Morang chose Knee's *Ascending Cloud* to illustrate his extensive review of the annual exhibition. She must have been de-

lighted at his praise. Never would it have occurred to her to object to a high ranking only among women painters. Where, we wonder, would Morang have placed her in relation to all painters?

Reviews like these helped to make Knee better known in the Southwest. She began to win a few prizes for her work: Second prizes at the California Watercolor Society shows in 1938 and 1939 were followed by first prizes at the New Mexico State Fair in 1939 and 1941. Even more exciting was the inclusion of one of her paintings in the 1939 New York World's Fair exhibition. Knee later received word through friends that Alfred Barr of the Museum of Modern Art had nearly purchased her painting for the museum.[30]

By then she had also had her first solo show, at the Denver Art Museum. Held in the spring of 1938, the exhibition elicited favorable comments. Museum director Donald Bear wrote:

> Her use of color, the division of her passages of the landscape material, of trees, of skies, mountains and rocks are handled with purity of painting and an appreciation which seems three-fold. Her conception of a picture begins authentically with nature. Her emotional realization is accurate. Her result is decorative and exciting. The combination of various appeals, though lyrical, brings forth something newly seasoned and at the same time, highly sophisticated.[31]

The director understood Knee's emphasis on retaining ties with nature. Asked in an interview that same year whether she identified with the Transcendental Painting Group (a group of New Mexico-based nonobjective artists), Knee replied, "No, although I exhibited first in Santa Fe with some of the painters who comprise that group. I could not belong because my starting point is objective. I go to nature for my inspiration. I am not a non-objective painter."[32] Despite her

decision not to join the TPG, Knee's nature-inspired abstractions allied her with certain of its members, particularly William Lumpkins, whose work also contained landscape references. Knee's 1938 *Indian Tree Fantasy* (plate 4) partakes of the animism of works like Lumpkins's *Dancing Trees* (1930). Both artists sought visual equivalents for the rhythms in nature.

Clearer by now about her artistic direction and knowledgeable about art in general, Knee was asked to share her skills as a teacher. She taught art at a Santa Fe girls school and had individual pupils from time to time. Nancy Thompson Taylor remembers taking painting lessons from Knee in the late 1930s. After some weeks of working together at Knee's Tesuque studio, the artist suggested that Taylor and her fellow students stage an exhibition of their work in August 1938. They issued invitations, hung their work carefully, and enjoyed the visitors' response as they wandered through the studio. The single sale made from the show was a work by a male student. Knee was a bit dismayed but not surprised. She pulled Taylor aside and consoled her, saying, "Well of course he made a sale—he's a man!"[33] Despite her own small successes, the artist held the view that, all other things being equal, a man was much more likely than a woman to make it as an artist. It would prove to be a self-fulfilling prophecy for her own career.

Teaching was something Gina did mostly as a gesture of friendship, but it produced some benefit for her own art as well. A few years later she explained, "Every once in a while I like having a pupil . . . because it somehow brings things clearer to me when I talk about them to someone who is right for that kind of talk."[34] Knee was not the kind of artist who thrived on solitude—who needed to isolate herself from distractions.

One thinks here of Georgia O'Keeffe, another woman working in New Mexico in the 1930s. O'Keeffe's New Mexico residence during these years was seasonal, however; not until the late forties did she settle permanently in the state. That peri-

odicity and her natural inclination to solitude kept O'Keeffe apart from most other New Mexico painters. She made a commitment to the Southwest landscape; that much she shared with Gina Knee. Beyond that, the two lives and the two artistic orientations diverged sharply.

O'Keeffe's artistic training and early aptitude contributed to her early success. She developed her considerable gifts under teachers who gave her the best of traditional and progressive training. By contrast, Knee in the late thirties was still unsure of herself as an artist and was largely self-taught. O'Keeffe, only eleven years older, was worlds ahead in the maturity of her art. Promoted by a dealer/husband convinced that a woman could produce modern art as powerful as that of any man, O'Keeffe was surrounded early by such Stieglitz cronies as Marin, Marsden Hartley, Arthur Dove, and Paul Strand. She was considered their equal, and her husband made her a legend.

Knee admired such luminaries from afar; her world and that of the Stieglitz circle rarely overlapped, with one notable exception. When he worked in New Mexico in the early 1930s, Paul Strand met Gina and Ernest Knee. During one of his visits, probably in 1932, Strand photographed Gina. His handsome portrait of her, features silhouetted against the sky, (fig. 15) compares favorably with Strand's portraits of O'Keeffe and his wife Rebecca made during those years. These are women of individuality and character. The camera has captured of Gina what Willard Nash's brush failed to record: identity, firmness of will, beauty of a deeper order.

That O'Keeffe's reputation was nurtured by her husband is undisputed. A *Life* magazine spread in 1938 made her the most famous woman artist in the country. The following year, as Knee was celebrating a modest accomplishment (the exhibition of her painting at the New York World's Fair), a Fair committee listed O'Keeffe as among the twelve most outstanding women of the past fifty years. It was a momentary

nexus between a giant of modern art and a virtual unknown. Knee certainly knew O'Keeffe's work; one wonders if the latter ever took note of a Knee painting.

As the 1930s ended, Gina Knee began to look for ways to expand her art and her connections in the art world. With her friend Cady Wells she joined the Heptagon Group in Taos in 1939. Centered around a gallery of the same name founded in the early thirties by painter Emil Bisttram, the Heptagon was the commercial voice of modernism in Taos. Its exhibitions reflected a diversity of styles ranging from the austere elegance of Andrew Dasburg to the lush colorations of Barbara Latham. They were united, as one of their exhibition brochures explained, by an expansive, Aristotelian attitude towards nature: "We must not imitate Nature in her effects, but rather follow her in her laws and principles. Only in so doing, may we hope to create works comparable to hers."[35]

Knee produced her most successful New Mexico watercolor, *Near Cordova, New Mexico,* in 1943 after more than a year spent in Los Angeles (plate 6). By now color had become a vibrant pictorial language. Gleeful, melodious, bursting with energy, *Near Cordova* is a rare instance in which the artist released her inhibitions along with her brush. The result is a visual excitement that moves, like a sprightly dance, across the paper. *Near Cordova* begins with a response to the physical world; church, crosses, and tiny buildings suggest the remote northern New Mexico village. But then Knee moves with breathtaking swiftness into a syncopated, almost explosive rhythm that invades land forms, buildings, even the air that envelops it all. Bold black lines clarify certain areas while other passages are deliberately blurred. Knee wanted the viewer to experience this energetic painting with all the sensory equipment available: Sight, hearing, and smell all come into play. The artist, after a restless period in California, had returned with renewed joy and a flow of high feeling to the New Mexico landscape.

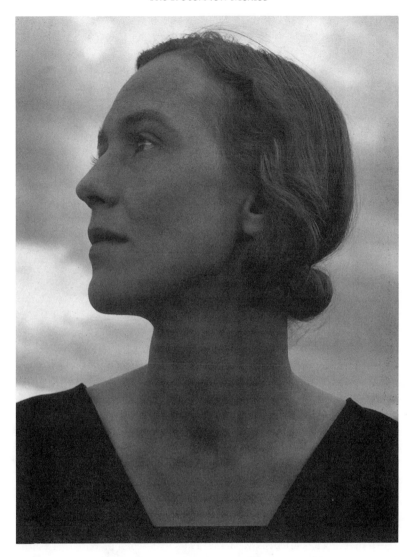

Figure 15. Paul Strand, *Gina Schnaufer Knee Brook, New Mexico*, c. 1930–32, silver gelatin print, copyright 1989, Aperture Foundation, Inc., Paul Strand Archive.

The same high spirits had been revealed in another painting made in the last part of Knee's residence in the Southwest. As the title suggests, *Circus Memories*, 1941 (fig. 16), is based on re-called images mixed with fantasy—a sea of free associations triggered by the word *circus*. It's a razzle-dazzle world of non-

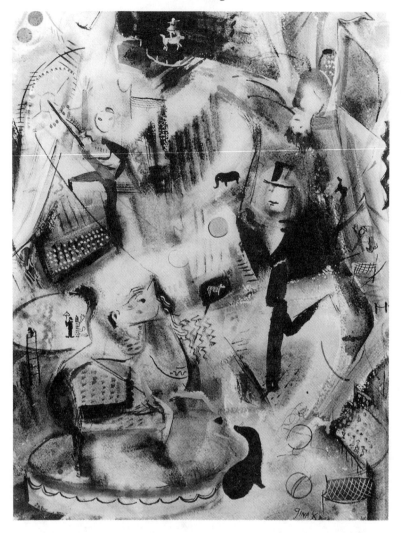

Figure 16. Gina Knee, *Circus Memories*, 1941, watercolor on paper, 24 x 20 in. Photo courtesy Miani Johnson.

stop gaiety where animals and circus performers invade one another's space and upset normal constraints of gravity in the process. As if she's said it all without taking a breath, Knee gives us the circus in an uninterrupted flow of images. In spaces between the larger figures of ringmaster, prancing horse, and trapeze artist she inserts tiny camels, zebras,

clowns. The all-over incidents give the impression of a *horror vacui*. Is Knee so afraid of dead passages in a painting that she must fill every corner with activity?

One is tempted, again, to seek comparisons with the work of other artists. Countless painters and sculptors, among them Alexander Calder, Pablo Picasso, and Walt Kuhn, have used circus imagery in this century. Closer to home, New Mexico artists whose work Knee knew also dealt with the circus: Ernest Blumenschein, Howard Cook, Russel Vernon Hunter, and summer visitor John Sloan all incorporated circus or carnival themes into their work. So did John Marin, whom one guesses may have again influenced Knee's subject choice. During the 1940s Marin made sketches and watercolors of the circus—lively records of the color and orchestrated movements under the big top.[36]

Beyond its visual immediacy, Knee's *Circus Memories* tempts the viewer to examine the painting's possible symbolic content. Does the artist feel like the the tightrope walker, whose performance is controlled by the tuxedoed ringmaster? Without a man at its center, would life dissolve into incoherent fragments? Alfred Morang, the incisive Santa Fe critic, noted the quality of personalized fantasy in Knee's work. In an article early in the year he had written, "Gina Knee is a watercolorist of exceptional ability. To her form and color become related into an abstraction of nature. Like John Marin, she combines visual and mental impressions into a highly personal art. Unlike Marin, she possesses a sense of fantasy that is at once amusing and profound."[37]

Another artist Knee respected, B. J. O. Nordfeldt, also had seen something new emerging in her work. Nordfeldt, an expressionist painter of considerable breadth, lived in Santa Fe from 1919 to 1937. Invited by Ward Lockwood to the University of Texas as a visiting professor in the early 1940s, Nordfeldt returned occasionally to New Mexico, where he renewed his acquaintance with the Knees. When he saw *Circus Memories*

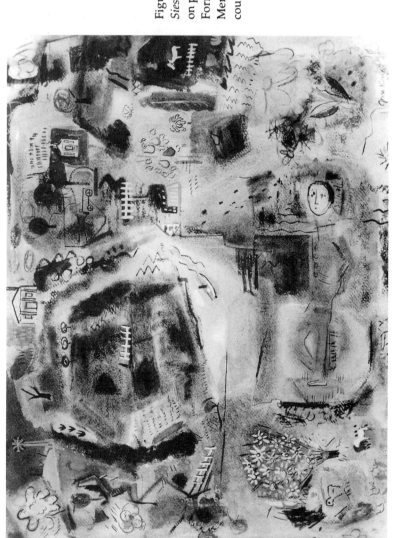

Figure 17. Gina Knee, *Siesta*, 1941, watercolor on paper, 18 x 22 in. Formerly, collection of Meredith Hare. Photo courtesy Miani Johnson.

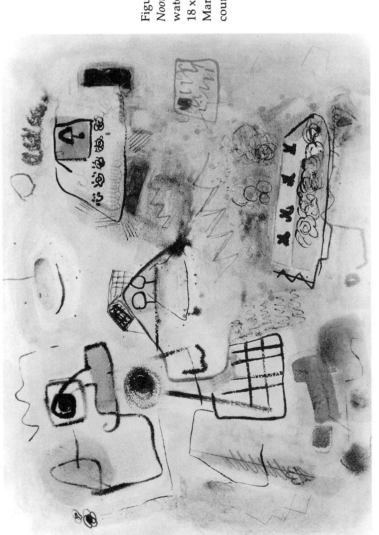

Figure 18. Gina Knee, *Noonday Jubilee*, 1941, watercolor on paper, 18 x 22 in. Collection of Marian Willard. Photo courtesy Miani Johnson.

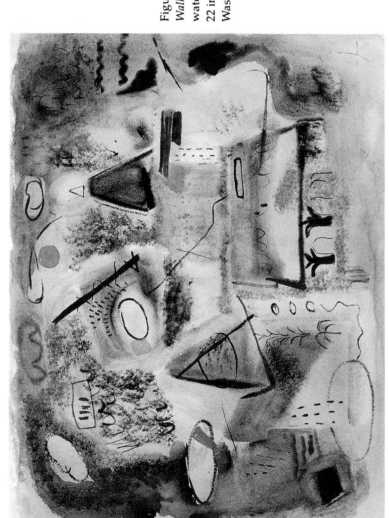

Figure 19. Gina Knee, *A Walk in the Rain*, 1941, watercolor on paper, 18 x 22 in. Phillips Collection, Washington, D. C.

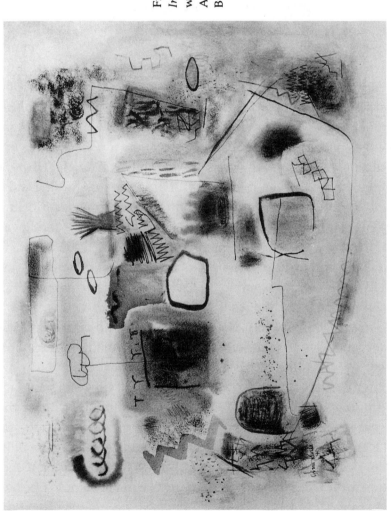

Figure 20. Gina Knee, *Indian Summer*, 1941, watercolor on paper. Albright-Knox Gallery, Buffalo.

during the summer of 1941, he told Gina he saw in it the accumulation of a particular and personal life experience that was universal. For this reason, and its elusive, interwoven rhythm and pattern, he felt the work would endure.[38]

The summer of 1941 was a particularly productive one for Gina Knee. Enjoying the cultivated Eden she and Ernie had created at Tesuque, she reveled in each day's richness and variety. *Siesta* (fig. 17) brings a rush of remembered images to her recumbent self, while *Noonday Jubilee* (fig. 18) releases line to indulge in lively Miroesque play. *A Walk in the Rain* (fig. 19) evokes the experience of New Mexico's capricious summer weather—sun and rain alternating to delight and confound expectations. The painting captures the watery feeling of a shower-dampened world. Fluid paint applied in translucent washes is a literal record of the way rain blurs the distinct edges of things and softens the feel of the air. Over these liquid passages Knee stroked linear details: Triangles, rectangles, and ovoid shapes repeat themselves as roofs, fields, clouds, and puddles. Rivulets of line, like rainwater trickling along the path of least resistance, link shapes to one another as if in some cryptic sequence of glyphs.

Through these and many other sensory experiences Knee led her increasingly agile brush. But with the coming of fall the Knees' New Mexico idyll was drawing to a close. *Indian Summer*, 1941 (fig. 20), harvests the color and richness of the season. Change was in the air, echoed formally in the painting's abrupt line shifts: Now curved, now calligraphic, now angular, they stop and start with impunity, suggesting but not limiting shapes. Space and form interact freely, bringing the character of one color or one density into contact with another.

The colder winds of autumn anticipated events that would change forever the life Gina and Ernie had built during a decade in New Mexico. Ahead was the war, which would relocate them to California. New people, new experiences, new di-

mensions in her art awaited. Yet the imprint of the Southwest would remain. As a woman in her seventies she would remark, "I never got over New Mexico—the landscape, the mesas, mountains, the green and tan."[39]

Notes

1. See Sheldon Reich, *John Marin: A Stylistic Analysis and Catalogue Raisonné* (Tucson: University of Arizona Press, 1970) and Ruth E. Fine, *John Marin* (Washington: National Gallery of Art and Abbeville Press, 1990).

2. On these two artists, see Charles C. Eldredge, *Ward Lockwood 1894–1963* (Lawrence: University of Kansas Museum of Art, 1974); Van Deren Coke, *Andrew Dasburg* (Albuquerque: University of New Mexico Press, 1979); and Sharyn R. Udall, *Modernist Painting in New Mexico 1913–1935* (Albuquerque: University of New Mexico Press, 1984).

3. See Eldredge, *Ward Lockwood*, pl. III-6, andd Fine, *John Marin*, fig. 215; Gina Knee, 1973 interview with Charles Eldredge, cited in Eldredge, *Ward Lockwood*, 43.

4. Fine, *John Marin*, fig. 217.

5. "Gina Schnaufer," in *Rio Grande Painters*, (Santa Fe: Rydal, n.d. [1933]), n.p.

6. Quoted in *Mallarmé*, ed. Anthony Hartley (Baltimore: Penguin, 1965), p. IX.

7. Gina Knee to Marian Willard, 30 Mar. 1943. Willard Gallery Papers, owned by Miani Johnson, hereafter cited as WGP.

8. "Vignette: Ernie Knee," *Santa Fean* (Jan.–Feb. 1980): 37.

9. Myron Brinig, "The Rio Grande Painters Bow," *Santa Fe New Mexican*, 30 Oct. 1933, 4.

10. A copy of the letter is in the Spud Johnson Papers, Harry Ransom Humanities Research Center, University of Texas at Austin, hereafter cited as Johnson Papers.

11. For more on the cultural conflict surrounding Indian ceremonials, see my article "The Irresistible Other: Hopi Ritual Drama and Euro-American Audiences," *Drama Review* 36, no. 2 (Summer 1992): 23–43.

12. Gina Knee, *Monkey in the Mirror: A Satirical Comedy in One Act* (New York: Samuel French, 1939), 3.

13. Ina Sizer Cassidy, "Art and Artists of New Mexico: Gina Knee," *New Mexico* Magazine (Feb. 1939): 38. For more on these illustrations, see my *Spud Johnson and Laughing Horse* (Albuquerque: University of New Mexico Press, 1994).

14. The following articles in the *Santa Fe New Mexican* record plans and reports of the "Deep Sea Baile": "Artists Plan 'Deep Sea' Ball Here on Night of April 22," 3 Mar. 1933, 2; "Santa Fe Takes a Dive into Deep Blue at Baile Tonight," 22 Apr. 1933, 2; and "Baile Brings Up Gorgeous Creatures From the Depths," 26 Apr. 1933, 2.

15. See the film *Remembering Edward Weston* by David Turner and Tom McCarthy (Santa Fe: Museum of Fine Arts, Museum of New Mexico, 1992).

16. Van Deren Coke, *Photography in New Mexico: From the Daguerreotype to the Present* (Albuquerque: University of New Mexico Press), 28.

17. Knee seems to have painted several versions of this subject. A painting called *Spring Orchards* is listed as catalog number 90 in the Twenty-fifth Annual Exhibition of Painting and Sculpture of the Southwest at the Museum of New Mexico, Sept. 1938.

18. Before their deaths Aline and Eliot Porter allowed me to see the house they purchased from the Knees in the mid-1940s.

19. *Art Digest* (15 Dec. 1933): 13.

20. *American Magazine of Art* 27 (Nov. 1934): 613–15.

21. Unsigned review, *El Palacio* 39, nos. 10, 11, 12 (Sept. 1935): 56.

22. Gina Knee, quoted in Jack Graves, "The Star Talks to the Brooks, of Point House," *East Hampton Star*, 19 May 1977.

23. Unsigned review, *El Palacio* 41, nos. 11, 12, 13 (Sept. 1936): 58.

24. Unsigned review, *El Palacio* 37, nos. 25, 26 (June 1934): 195.

25. Henry McBride, "The Sign of the Cross," *New York Sun*, 8 Feb. 1930): 8.

26. Artist's statement, Gina Knee Retrospective Exhibition brochure, Skidmore College and Larcada Gallery, 1973, n.p.

27. Kenneth Clark, *Civilisation* (New York: Harper & Row, 1969), 66.

28. This painting also was known as *Ascending Clouds*.

29. Alfred Morang, "Twenty-Fifth Annual Show," *El Palacio* 45, nos. 9, 10, 11 (Aug.–Sept. 1938): 44.

30. Gina Knee to Marian Willard, n.d. [1942], WGP.

31. "Gina Knee Invents Fresh Idiom in Painting New Mexico, Says the Director of the Denver Art Museum," *Santa Fe New Mexican*, 2 May 1938, 2.

32. Cassidy, "Art and Artist," 23. Knee attended a dinner for the coalescing Transcendental Painting Group on June 7, 1938, but she thereafter decided (as she stated) that her artistic aims differed from those of the group. Present at the dinner were TPG members Emil Bisttram, Horace Towner Pierce, Florence M. Miller, William Lumpkins, Robert Gribbroek, Raymond Jonson, Dane Rudhyar, and Lawren Harris, the latter visiting from Canada. See Marianne Lorenz, "Kandinsky and Regional America," in Gail Levin and Marianne Lorenz, *Theme and Improvisation: Kandinsky and the American Avant-Garde 1912–1950* (Boston: Little Brown, 1992), n 43, pp. 165-66.

33. Nancy Thompson Taylor to author, 1989. See also "Gina Knee's Pupils Exhibit Their Delightful Freshness of Appeal in Water Colors," *Santa Fe New Mexican*, 30 Aug. 1938, 2.

34. Gina Knee to Marian Willard, n.d. [contextually, 1942], WGP.

35. Taos Heptagon Group brochure, Johnson Papers.

36. Several Marin sketches and paintings of circus themes are illustrated in Fine, *John Marin*, 256–57.

37. Alfred Morang, "To Think of Santa Fe is to Think of Its Painters," *Santa Fean* 1, no. 9 (Mar.–Apr. 1941): 42.

38. Paraphrase of Nordfeldt's verbal statement, Gina Knee to Marian Willard, spring 1942, WGP.

39. Quoted in Graves, "The Star Talks."

2

THE 1940S: CALIFORNIA, GEORGIA, AND NEW YORK

Two events in the early 1940s were to have a lasting effect on Gina Knee. The first was the entry of the United States into World War II; the second, a more personal kind of disruption. In December 1941 the bombing of Pearl Harbor instantly galvanized American sentiments against the Japanese. Even in relatively isolated New Mexico (where a few years later the secret Manhattan Project at Los Alamos would produce the atomic bomb that hastened the war's end) people felt a simultaneous dread of the conflict and a determination to defend America's shores.

After Pearl Harbor the draft moved rapidly to increase American military strength, and Ernest Knee expected to be called. If drafted, he hoped to use his photographic skills in the war effort. While waiting he continued his photography work as best he could. But the Depression had finally reached New Mexico—later than most of the country—and there was little work to be had as a photographer.

As it turned out, his earlier health problems prevented a draft call. Soon Ernie, like many other New Mexicans, decided to forsake the dismal New Mexico economy to look for employment in the California defense industry. Leaving Gina

to paint and to care for the Tesuque house, he departed for Los Angeles, where he found work at a defense plant.

The outbreak of war distressed Gina Knee deeply. She had just begun to find recognition through her art when the horrifying destruction of a global conflict made everything else seem insignificant. Her sense of humanity was outraged, and she knew that an era of nearly idyllic artistic productivity in sleepy New Mexico was ending, perhaps forever. Yet by now art was a vital part of her life. In a letter written two days after Pearl Harbor she anticipated changes in her life but predicted, "I know I won't be able to *stop* painting no matter what else I have to do besides painting." Not only on a personal level but on a broader human plane, she knew that art is somehow essential to civilization, even in times of war. To a friend she insisted, "Of course I feel, and I know you feel too, that we have to work harder than ever to keep art alive."[1]

During those winter days in her Tesuque studio Gina painted a watercolor full of those inner feelings of uncertainty, frustration, and isolation. *Snowbound,* 1941 (fig. 21), is a densely packed composition with details crowding in upon one another like the stitched together fragments of a pictorial quilt. Every square inch is filled with textural or pictorial incident, keeping the viewer's eye moving constantly. There is no single center, no strict hierarchical ordering. Perceptions are fragmented, accelerated by thin geometric lines—zig-zagged roof lines, bird tracks, waves, window mullions. The patterns of snowflakes animate loosely brushed passages, and the foreground snow, drily brushed, has a melting, slushy quality.

But *Snowbound* is less about weather than about the complexities of women's lives. The artist took pains to clarify this a few months after she painted *Snowbound.* She wrote:

> The representational parts of this painting are more about a state of mind than about a winter scene. The ladies sit behind glass windows looking placidly into a frozen world of tangled objects.

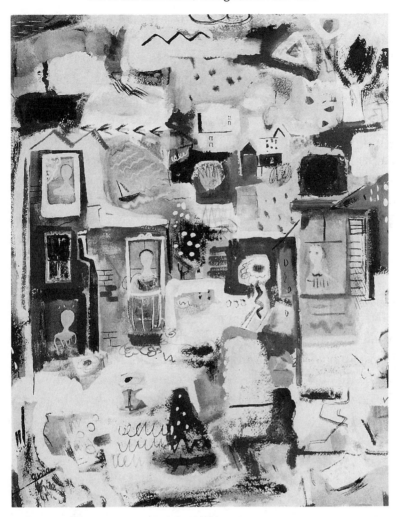

Figure 21. Gina Knee, *Snowbound*, 1941, watercolor on paper, 17 1/2 x 22 in. Photo courtesy Miani Johnson.

That the ladies go on sitting there, snowbound, is perhaps an objective statement, but I hope their suspended isolation makes more real the inner life of their surroundings, the outer world.[2]

Four women, three of them virtually faceless, stare blankly out of their separate windows, protected from the storm outside but

isolated within—one of the trade-offs women historically have made when they choose security over independence. The theme of pensive women at windows is an old, romantic one, strongly reminiscent of Victorian book illustrations. Perhaps Gina had seen such pictures in her girlhood; a few decades earlier, as one scholar has noted, the woman at the window was the most popular subject illustrated in English books from the 1850s through the 1870s.[3] Men, significantly, are as absent from Knee's windows as they are from the book illustrations. Their realm is an active one, abroad in the greater world (perhaps at war), distant from domestic concerns. As Gina Knee knew, it is most often women whose lives are circumscribed, passive, metaphorically "snowbound."

Snowbound and its layers of meaning anticipate the work of Louise Bourgeois, the French-born sculptor who in the mid-1940s began to make images even more graphic in their expression of women's surroundings. Her series of *Femme Maison* drawings, graphic realizations of sculptural forms, deal with "uneasy spaces" and women's body-houses, where the image of a selfless, faceless woman is trapped in the empty shell of a house. These, like Gina Knee's *Snowbound*, must be seen as highly autobiographical works where anxiety is pervasive.

Given her state of mind and the onset of world conflict, the "suspended isolation" Gina mentions in her description also parallels the personal disruptions of war, which isolated women from their men and fragmented their lives. Safely tucked into their houses, waiting, the women pause to think of times past, to worry over future dangers. Here, as in many paintings to come, Knee presents images that seem at once personal and universal; they resist fixed interpretations. We, in turn, need not feel compelled to fasten upon one meaning as more right than others; the artist's own amplitude and the critical temperament of the current era not only admit but en-

courage a satisfying multiplicity. We can float several meanings and swim among them all.

Though she probably did not set out deliberately to paint the details of her life, Knee often used her art to clarify her thinking. And in *Snowbound* she seems to be suggesting in a "frozen world of tangled objects" the static quality of women's lives. In the statement (quoted earlier) she wrote to accompany the painting, she originally added after the second sentence, "Objects whose lives have sound and scent and meaning." Objects, like women, count for something; both partake of the life force present in all things. All kinds of life forms interested the artist, and she looked for various ways to represent them. She added, "My way toward understanding the abstract forces and essences in things, in related living, in the cycle of growth, is through painting them."

In the years to follow, even as death raged on the battlefields of Europe and the Pacific, metaphors of growth, rebirth, and the interrelationship of things helped her to understand themes of life and death in her art. She often suggested such ideas through the metaphor of changing seasons. In *Snowbound* a sailboat here, a line of bird tracks there, a garden plot dormant under the snow all are reminders of the cycle of life. Spring will come again, the war will end, the women will tie up the broken threads of their lives.

The person to whom Gina confided her fears and hopes in the early forties was her new friend Marian Willard, whose personal and professional support would grow into one of the most important relationships of Gina's life. They had met in New York during one of Knee's occasional trips to visit friends and to see art in the city's museums and galleries. New York, long the crucible of America's art activity, was still the essential place to exhibit for any artist seeking widespread notice. Knee had already exhibited there in group shows at the 1939 World's Fair, the Whitney Museum, and the Riverside Museum, but she had never had a show of her own in New York.

During a visit to the city in 1941 she began to discuss that idea with dealer Marian Willard, and after her return to Santa Fe a flurry of letters completed arrangements for Gina's first solo exhibition in New York. It would be held at Willard's gallery early in 1942.

Knee's choice of a dealer was eminently suitable for both. Marian Willard was an energetic art promoter who had opened her first New York gallery some five years earlier. In 1940 she had moved it to a tiny rented space at 32 East Fifty-seventh Street, which she called the Willard Gallery. Single, younger by six years than Gina Knee, Willard had long been a student and collector of art, learning art history and studying art independently in Italy. Willard's was a highly personal conception of art, based on the belief that psychological thought and contemporary art were interrelated and universally significant. She found the key to these relationships in Carl Jung's theories, particularly the premise that mythic images lead us back to experiential nodes and boundaries. His writings had begun to interest Willard in the late 1920s, and in the mid-thirties she spent two summers in Zurich attending Jung's lectures. Convinced that Paul Klee's work embodied Jung's theories and that Klee's artistic content held special psychological significance for the twentieth century, Willard began to purchase his paintings, then to exhibit Klee at her gallery. Throughout her four decades of gallery ownership, Willard was strongly attracted to abstract and semiabstract art in which she perceived deep underlying meaning. This content—symbolic, universal, and often spiritual—was for Willard (and for Klee) the greater reality behind visual things.

Such ideas were perfectly congruent with the emerging subjectivity in Gina Knee's art. From her landscapes and figure studies of the 1930s she had begun to move, as in *Snowbound*, to a new understanding of art's potential for inner meaning. This approach, essentially intuitive, was very appealing to Knee; she already had come to think of abstraction

as no mere deviation from reality but as the ideal vehicle for conveying the essences of life and art. Her imagery was becoming more abstract but, in its closeness to organic shapes and sources, it retained close ties to nature.

Knee's and Willard's ideas were in a tiny minority among American artists and dealers in the 1940s. At least three other major approaches were more visible. Most American painters, for example, were still making representational art with regional themes and content. Soon Surrealism, with its roots in dreams, the unconscious, and Freudian theory, would make an impact on the New York art scene through the arrival of European emigrés. Certain aspects of Surrealism interested Willard, but she preferred Jung's universality and archetypal thinking to the rigidity of Freudian theory.

Taking hold even more firmly during those years were the precepts of formalist criticism, voiced most clearly by Clement Greenberg. This theory posited that art is self-contained and objectively verifiable and follows unchangeable laws. Quality was to be determined by self-criticism, self-definition, and the elimination of elements from other disciplines. The art itself was value free, usually nonfigurative, and divorced from social and historical contexts. Opticality and problems of visuality preoccupied formalist critics, for whom externally apprehended (not subjective, spiritual, or intuitive) criteria were paramount.

Fortunately for Gina Knee, Marian Willard differed from most other New York dealers in her relative inattention to formalist or modernist criticism. Willard cared little how fashionable or experimental was the art she showed. She refused to follow the parade of sequential "isms" that addressed form, abstraction, and the avant garde for their own sakes. Willard was much more interested in exhibiting work she felt had universal significance, deeper meaning. As such, the artists she showed over the years often had an archetypal content in common. Though some of Willard's artists, such as David Smith,

67

Lionel Feininger, Mark Tobey, and Morris Graves, are widely known today, more representative were the experiences of artists like Gina Knee and the early Loren MacIver, whose paintings of numinous images and expansive content appealed to a more specialized audience.

Gina Knee's sensitive handling of watercolor and her intuitive approach to painting promised paintings Willard could support enthusiastically. The dealer introduced her to Klee's work and ideas and encouraged a delicacy and nascent playfulness in her work. Fantasy, the key element in much of Klee's work, began to find its way into Knee's painting as well. She discovered that while elemental nature could remain a source of myth and energy, there were new, surprising and vivid ways of playing with its character. She looked beyond Klee for the sources that had inspired him: An affinity for children's art, which she explored through the writings of the Austrian teacher Cizek, encouraged spontaneity and release of inner creativity. From so-called primitive art, ranging from African masks to pre-Columbian sculpture and the stylizations of Southwest Indian art, she learned directness and immediacy, the skills of stylization and simplification.

Klee's formal experiments were constructed like his thought processes. He spoke of "going for a walk with a line." Lines, he knew, can move tentatively, meandering through the picture space; or they can stride assertively through uncharted territory. Thinness or thickness, continuity or disjuncture—all these describe the mood and structure conveyed by lines. Gina Knee too had experimented with the range and diversity of lines: short, choppy lines may expose raw, unfocused energy, as in her *Near Cordova* (plate 6). Or they can help to define and activate space, creating something like meaning through the very process of painting. Such new ideas were mingled with longstanding formal concerns as Knee prepared the dozen paintings for her first exhibition at the Willard Gallery in 1942.

Her medium, though still technically watercolor, by now often included tempera and gouache as well—whatever combination brought forth her desired texture. Her show was scheduled for April and May, between exhibitions of the work of André Masson and Lionel Feininger. Knee admired the personalized abstractions of both men and wanted her work to hold up strongly in comparison to theirs. In letters to Willard she expressed the difficulty of selecting and preparing the paintings. She fretted over big and small things and related how the pressure of her first New York solo show affected her: "I have been in lots of shows and I've had other one man shows before this without going the least bit crazy but this time I must be upset because it's New York and I've seen so many painters go bitter and cynical after New York. The war too makes a difference."[4] To her jangled pre-exhibition nerves Knee attributed strange dreams and "unprecedented minor injuries." Laughing at her own clumsiness, she told Willard of a comical string of misfortunes: For no apparent reason she fell in the dining room and broke a finger, developed an abcessed tooth, and drove the car into a telephone pole on a Santa Fe street.

Part of the difficulty was the fast-approaching deadline. A creative burst in the last two months before the show had produced new work but had left her dissatisfied with some of the older paintings. "I have been painting constantly," she wrote to Willard, "and two of the best things . . . were done last week. About a month ago I started unconsciously working in a more lucid way and they are so much more articulate that this recent work makes most of the things from last year look forced and rather heavy handed."[5] And yet, as she contended with new formal issues and the changing nuances she wanted to convey in the content of her paintings, she found her self-criticism ever more rigorous. Painting had come relatively easily in past years; it had seemed to flow from her brush, unforced.

Now, struggling with her increased awareness of its potential, she set herself more difficult challenges.

She was concerned that the show would not produce a unified visual effect in Willard's gallery because of her rapidly changing work. Perhaps, she thought, it was due to her own mercurial emotions, identified in her mind with her femaleness:

> Of course in such personal painting the mood changes constantly and I have been conscious of this in arranging the show but I can't possibly make a group of twelve paintings present a single impact. . . . In showing my things separately I find that there is a positive response to each individual painting but when they are seen all hung together most people can't see them individually and they are baffled by all the conflicting moods—sort of like having all the courses served up at once or seeing a female in a range of emotions in a few moments.[6]

She would trust Willard to hang the paintings harmoniously, to finalize her tentative prices, and to prepare a brief biographical statement for the exhibition brochure. At first artist and dealer considered posting a short poetic statement alongside each painting. This idea originated in the poetic responses of a friend to Gina's watercolors. Willard "Spud" Johnson, New Mexico poet, critic, and editor of *The Laughing Horse*, was a strong admirer of Knee's work and wrote a vivid "impression" of each of the dozen paintings prepared for the New York show. One example, about a painting titled *After Dark*, read, "Always the night is mysterious. Anything may happen. Prowling animals, strange ghostly shapes and noises, sudden steps—these may be horrible. White palings of a fence, black doorways, lighted windows, these become awesome. After dark, even a mouse is a burglar, and at night a dog's howl is always wolves." Evocative of her painting's

moods, the words of Spud Johnson initially seemed an ideal accompaniment to the watercolors. Knee and Johnson even considered publishing them together in a book. But as the time of the exhibition drew nearer, she began to have second thoughts about the "impressions" as accompaniments to her paintings. Wouldn't it be too much like "program notes," she wondered? Could words, after all, "explain" paintings? Should they try? In the end, Knee and Willard decided not to juxtapose the poetry and paintings. Instead, Johnson published them in a literary quarterly.[7]

Still, details of the exhibition remained to be decided. The paintings needed titles, carefully chosen to engage the viewer's sensory capacities. She told Willard, "I wish I could call my things by names such as 'The Taste and Smell of the Sea'—instead of 'Seascape' but I think it sounds precious, and besides I think just 'Seascape' leaves more to the imaginative talents of the observer—it makes him independent of the artist and his reaction is consequently a creative thing in itself."[8]

It mattered very much to Gina Knee what viewers found in her paintings. Her relatedness to others, a trait women often mention about themselves, meant that to a certain extent she relied on others to validate her artistic efforts. In fact, as she considered when assigning titles, she felt that the viewer completed the meaning of the work. She arrived at these kinds of attitudes intuitively, never suspecting that a half century later they would find currency as "viewer-oriented criticism," "viewer-response criticism," or, more broadly, "reception theory." These are all names for the recent field of inquiry in art (and literary) studies that foregrounds the role of the viewer in understanding and finding pleasure in art. A painting or sculpture is a "text" that acquires meaning through the process of viewing.[9] In other words, reception theory holds that meaning no longer resides exclusively in the "text" but is the result of a confrontation between the act of viewing and textual structure. With the acceptance of this broadly applied re-

ception theory, the act of looking finally has been admitted to the critical agenda. Knee, whose attention to formal theory was scant, knew fifty years ago that her work must connect with a viewer to achieve completion.

She valued the general viewer's opinion, but she knew that it was the reaction of critics that could make or break an artist in New York. Good critical reviews would bring people to the gallery in the first place; bad notices would keep many away and probably prevent some sales. Knee feared that critics might label her work as derivative. She openly acknowledged the influence of Klee in her current work, just as she had spoken of Marin's inspiration in earlier years. But she didn't want to be dismissed as a blind follower of Klee. "I am upset," she wrote Marian Willard, "for fear I'll get stamped as an imitator. . . . I've been trying to let my own work flow naturally— and then when the result *looks like Klee* or seems to me rather not to be completely my own I destroy it." She understood her own anxiety of influence—that she was sensitive to and attuned to Klee's imagery, as in her *Figure in Landscape,* 1942 (fig. 22); but she knew too that her work grew out of her own experience and her own visualization of interior states.

Would critics understand that? Or would they assess her as a mere synthesizer at a time when innovation, that godlike activity ascribed mostly to male genius, reigned supreme? If that happened, would people buy her work merely because they couldn't afford Klee's? All these things bothered Knee to distraction, and she wrote Willard urging her to cancel the show if she shared such doubts. But Willard—by now confidante, sometime confessor, and staunch artistic backer—assured the artist of her support and her confidence in the work's artistic integrity.

Both Knee and Willard worked hard to publicize the exhibit. To the gallery's standard mailing list Knee added the names of many East Coast friends and collectors. Sales were not a primary concern, but sales were one measure of accep-

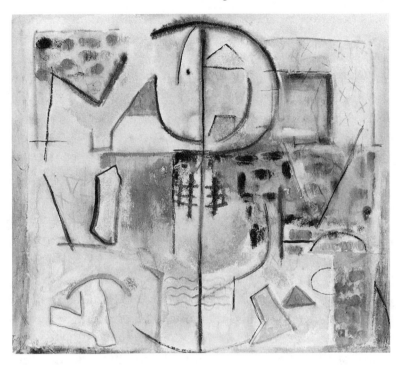

Figure 22. Gina Knee, *Figure in Landscape*, 1942, watercolor on paper, 14 1/4 x 10 1/2 in. Collection of Jonson Gallery of the University of New Mexico, Albuquerque.

tance, and Knee wanted to place her paintings with people who truly wanted them. Fortunately, she did not have to depend on the sale of paintings to support herself. To Willard she explained:

> I just want to pay for the frames and materials so if someone wants one which he cannot afford you may sell it as low as you want to. . . . I am always so moved when people want them that I'd almost rather give them away than sell. However, I don't feel that way about rich collectors or museums— I'm not *that* unworldly.[10]

As the show opened, Knee was still ambivalent about the results of her long months of effort. The final paintings were strong, but she knew she was in a period of rapid artistic transition. She felt ambivalent about critics seeing this work: "There are some very good things in my show and I have worked and discarded and discarded so that none of it is bad." Nonetheless, there were things left unsaid in the paintings: "I wish I were the kind of painter who could feel satisfied but I always feel that they could be better—more articulate or something."[11] She thought again of the insightful viewer she wanted to reach. Like Georgia O'Keeffe, who considered herself more articulate in paint than words, Knee counted on her paintings to "speak" for her and hoped to find a stronger voice with each new group of paintings: "I honestly want to emerge quietly into the New York public because I feel that I can say things in paint better next time but this time it is the best I can produce."[12]

Knee's emergence into the New York art world was modest, if not exactly quiet. Marian Willard and other friends urged her to come for the opening and to talk personally with the critics about her work. But Knee was reluctant, pleading that finances might prevent a trip at the moment. More likely she preferred to await her critical fate in far-off Santa Fe in case the critics were unkind, in case they saw only Klee in her work. She was unsure how to withstand hostile critical barbs and must have known they could wound her still-wobbly ego. Now that she had taken the great step from amateur painter to professional and had declared the importance of art in her life, more was at stake than ever before. This New York exhibition, the logical culmination of a long apprenticeship, would either mark her arrival as a professional or signal a symbolic banishment to regionalist status.

Willard felt no such apprehension. She invited all the important critics she knew, and many came to see Knee's watercolors. The *New York Herald Tribune*'s reviewer called them "sensitively imaginative in style" and noted the presence of

Klee's influence, but only in passing. He praised their "sooth-ing restraint, lovely color," and subtle, atmospheric quality.[13] Writing in the *New York Times*, Howard Devree made no men-tion of Klee but gave Gina a paragraph of praise that to mod-ern ears sounds faintly condescending. Obviously, Devree applied different standards to the work of men and women. Where he praised "virility" in male work reviewed in the same column, he found Knee's paintings merely "amusing," "clever," and "spirited . . . the pup in *First Kill*," he continued, "is one of the most engaging of animals."[14] Even more overtly gender oriented was the remark of the *Art News* critic, who likened some of her paintings to "samplers where things may be well ordered and on the same plane but which are [as] replete with little doings and objects as a notion counter."[15]

Knee was in no mood to complain. She was pleased to be reviewed at all, delighted that critics had found polite things to say. They did not seem at all bothered about disparity of mood or subject in her work; in fact, they seemed to welcome her breadth and range. They mentioned, as if pleasantly sur-prised, that she lived in Santa Fe, recalling perhaps the too-typical New Mexico paintings common a generation earlier. (Most New York critics had long ago tired of the high-keyed Romantic realist canvases of Indians and aspens spilling by the hundreds out of Taos and Santa Fe studios.) Knee's semi-abstract approach to her subjects helped counteract the critics' impression of sameness in much New Mexico painting. The *Art Digest* critic noted, for example, subtle and appealing vis-ual references to the Southwest: "Living in the heart of the In-dian Country in the southwest may have influenced Miss Knee's own sign language, like the composition *Distant Valley* [plate 5] with its suggestion of Indian symbols and *Five A.M.*, which has the texture of an artistically woven blanket."[16]

In this 1942 show *Snowbound* (fig. 21), *Indian Summer* (fig. 20), *Siesta* (fig. 17), and the other New Mexico-inspired works made up about half the show. *After Dark*, about which Spud

Johnson had written, was withdrawn at the last minute because artist and dealer felt it was jarringly different from the other paintings. The more recently completed paintings in the show are far less site specific than the earlier ones, suggesting a release of Knee's imagination to range freely outside familiar landscape bounds. Calling on states of mind, moods, and fantasy, paintings such as *Index to the Sea* and *A Walk in the Rain* (fig. 19) are intensely personal reactions to nature that signify the newer direction of Knee's work. More confident of her form language, she allows color and rich linear variation to replace the objective referents of the earlier work.

Willard showed *A Walk in the Rain* and *Snowbound* to collector Duncan Phillips, director of the Phillips Memorial Gallery (now the Phillips Collection) in Washington. He took them both on approval but after two months still couldn't decide which to keep. "I like one for its color and design [probably *Snowbound*] but the other for its delightfully childlike expressiveness," he told Willard.[17] After a summer's deliberation he kept *A Walk in the Rain*. *Snowbound* was returned, and Willard immediately sent it on for inclusion in the Metropolitan Museum of Art's "Artists for Victory" exhibition.

Phillips was the kind of collector Willard liked to work with—sensitive, with extremely personal tastes. Painter Jacob Kainen, who often talked art with Phillips, recalls of the collector, "He responded to the moody landscape, the enigmatic rather than the illustrative. He sought the 'painted lyric.' Certainly he disliked art that seemed to emerge from theory rather than from nature or feeling."[18] Phillips also collected the work of Klee and Morris Graves, among many others.

Willard cultivated a clientele who shared her philosophical aesthetic and appreciated the artists she showed repeatedly. Looking back on those years Willard recalled,

> In the old days you could count on a handful of people who might be interested in what you had. . . .

> There were interesting collections being formed
> then of artists, in depth, let's say. . . . I remember
> some collectors would come in year after year and
> ask to see the recent work of an artist in whom
> they were interested. You built up a clientele that
> way.[19]

Willard's clientele included both individual and institutional collectors. Another museum interested in Knee's paintings was the Albright Art Gallery in Buffalo (now the Albright-Knox Gallery). Its acting director, Andrew C. Ritchie, was delighted when patron P. J. Wickser purchased Knee's *Indian Summer* for the museum. Several other paintings were bought by well-known private collectors, including Meredith Hare, an influential arts patron in Colorado Springs.

The results of Knee's first solo New York show were extremely encouraging. The two sales to museums marked a new level of recognition and were public validation of the artist's explorations into subjective painting. After the reviews were in, the artist herself came to see the show and to share with Marian Willard their mutual achievement. Both were jubilant at the critical and commercial success they had orchestrated.

In addition to the show at the Willard Gallery, 1942 saw several of Knee's paintings touring the country in circulating shows. After her brief visit to New York she returned to Santa Fe and began painting with renewed confidence and enthusiasm. She ventured into a medium new to her, tempera with egg glazes. That fall, her work was included in the annual large Fiesta show at the Santa Fe museum, a vital cross-section of Southwestern painting. Alfred Morang, in his review for the *Art Digest*, wrote, "Gina Knee is probably the most important painter of well-controlled abstract-creative patterns in the country. Her color is intense even when she understates, a quality which she shares with only a very few living Americans."[20] The following month the White Gallery in Santa Fe gave her a solo show of her newest work; from there the paint-

ings were scheduled to travel to the University Art Gallery in Albuquerque and on to California.[21] Professionally, Knee was poised to press forward in her painting with renewed confidence and energy, but now obstacles arose.

By the time of the October exhibit, the life-changing events she had anticipated after Pearl Harbor were underway. The war, escalating monthly, reached closer, interrupting the Knees' tranquil Santa Fe life. Ernie had already departed for Los Angeles to look for work in the aircraft industry. Gina had expected to stay on in New Mexico to paint, but the Tesuque house proved far too large for one person. Besides, wartime scarcities made it impractical to shuttle the four miles back and forth to town for food, gasoline and art supplies. So she found tenants for the house and moved to a small apartment in Santa Fe.

There she tried to work, to sustain the creative path she saw before her. But the solitude of the country was replaced in sociable Santa Fe by frequent interruptions from well-meaning friends. They stopped by to keep her company and phoned with invitations to dinner. Soon any hope of working vanished. The apartment was cold, her dogs often escaped over the adobe wall to threaten the ducks next door, and she was besieged with phone calls from the Tesuque tenants about the smallest household details. These were the minor irritants that kept her from working. But she knew the real difficulty lay deeper, in her separation from Ernie.

By December she had had enough. She decided to join him in Los Angeles. Quickly, she sold seven paintings directly from the studio, sent three to the Willard Gallery, and dispatched two others to group exhibitions. Impatient to leave, she put household furnishings into storage, shipped the remaining paintings and her art supplies to Los Angeles, and arranged with a friend to drive to California. By December 21 she was with Ernie in a temporary apartment on Wilshire Boulevard. The next day she wrote Marian Willard that she

felt her decision to come was right and wise. In the months of absence from Ernie she had realized his significant though passive role in her art-making. One couldn't call it support, exactly, at least not in the usual sense. She tried to explain it to Willard:

> Most of all my reason for leaving [Santa Fe] was the surprising but deep realization that I couldn't feel my world of work and living as a complete and unified thing and each time I tried to paint it was stronger than ever—that realization that something was missing, something vital and strengthgiving and I found that I had never valued rightly the force and the calming influence that I'd gotten from Ernie.
>
> I remember the things you said about stimulation of his kind when I told you that he did not appear interested in my work. It is that very presence of disinterestedness, of forcing me into a solitary position where I stand my ground alone that is necessary to my restless nature. He has never resented my hours of work and never interfered and I can see that that state will go on.[22]

Paradoxically, then, it was a certain psychological apartness, coupled with a physical closeness, that Ernie contributed to her work. Seen this way, his was the silent presence, the unseen witness who forced her to contemplate what she was painting and why. His careful, discerning photographer's eye took in more than he revealed; what he left unsaid had to be filled in by Gina herself through internal dialogue with her own work. Glib praise would have served her less well, and she now knew it.

Reunited with Ernie, she hoped the ensuing months would be productive for her painting. First, though, they needed to find a permanent place to live. The Wilshire apartment was filled with welcome sunshine but otherwise represented what

Gina disliked most about modern urban living. It was "too elegant and too mauve and not equipped for anything except drinking and sleeping."[23] There was a pink bathtub but no stove; a good bed but no place for books; a spotless sea-green rug but no drawers for keeping the necessities of life. One could not really *live* there; it was a place for perpetual tourists. For Gina, the most serious of the apartment's deficiencies was its lack of studio space.

The painting supplies shipped from Santa Fe in mid-December had not arrived. So to keep from losing momentum, she worked at drawing. Then, in early January, a folio of André Masson drawings appeared, sent by Marian Willard, a close friend and New York dealer of the exiled Surrealist painter. She had sent them knowing that Gina would respond to Masson's delicacy and spatial complexity. Knee had seen his work at the Willard Gallery the previous spring, but the pioneering French painter was undergoing a major change in style, inspired by his new residence in the Connecticut countryside. In his painting Masson was experimenting with abstract patterning and fantasy imagery based on earth-derived organisms. And in his spontaneously realized drawings he continued to explore the possibilities of automatism, the Surrealists' means of releasing material dredged from the unconscious. It was a little like the "doodling" of Klee, though based on a somewhat different premise.

Knee, whose own work had nascent affinities for biomorphic forms, saw in the Masson drawings new points of departure (*Abstraction*; plate 7). Writing to Willard, she explained that looking at her favorite among the Masson drawings was "like dropping into a vast dry lake where the silence is so heavy it seems filled with all the sounds of the earth's life— sounds which on coming together produce no sound like all colors mixed together produce no color."[24] Sound and color were comparable for Knee. They were mutually enriching, part of the concept of synesthesia, the overlap between the

senses Gina had discovered in New Mexico. Knee was not alone in exploring the prospect of intermingling senses; the idea that colors can speak or that sounds can ring musically has intrigued numerous artists and writers throughout the ages. Synethesia received a revival of interest in the nineteenth century that carried over into the twentieth.

Gina Knee was highly receptive to the concept of synesthesia, though she lacked full awareness of its historical import. It held special and highly personal poignancy for her. She had already spoken of her wish to incorporate nonvisual sensory experience into her paintings (and their titles, as in *Tree Sounds*, exhibited in the 1942 Willard show), but now she began to think of sound as a distinct variable in her work: Its presence or absence could be equally significant. A few months later she would paint *Night Sounds* and *Quiet Life of a Bird's Egg*, two paintings that establish mood through the interaction of shape, color, and imagined sound.

In January the Knees found a house on Bentley Avenue, got their dogs out of the kennel, and tried to normalize their living arrangements again. They began to explore Los Angeles, to look up old acquaintances, and to look at West Coast art. They went to a few gallery openings, where the crowd was sometimes more interesting than the art. At one show, Gina met photographer Man Ray and the German exiled author Thomas Mann, who, along with European intellectuals such as Aldous Huxley, Bertold Brecht, and Jean Renoir, made their home in Los Angeles during the war years. The art wasn't always as scintillating as the conversation, however; at one opening Gina described the paintings as an unfortunate mix of "Harper's Bazaar and the Godey fashion book." Too often the talk about art was a "floating mass of smart, superficial, artificial art 'appreciation'" with only an occasional perceptive eye. When she met a collector whose sensibilities matched her own, she was overjoyed to find someone "different and right and clear."[25]

A vital force on the Los Angeles art scene was dealer Dalzell Hatfield. His clients were a mixture of serious collectors and well-heeled celebrities eager to acquire the cachet of art collecting. Artists respected Hatfield's gallery in the Ambassador Hotel, and many more portfolios were shown him than he could ever exhibit. Because Gina had been in a group show with other New Mexico painters at the Hatfield Gallery a few years earlier, the dealer already knew her work. (He also was familiar with Ernie's work and later arranged for the first show of his photographs in New York.) When Hatfield saw Gina's recent paintings, he immediately offered her a solo show in Los Angeles.

Hatfield wanted to exhibit Gina's work during April, just two months away. And Marian Willard was asking for another New York show soon after. Having sold some of her best work before leaving New Mexico, Knee didn't have enough paintings on hand to fill even one of the shows. It would be necessary to paint, and paint quickly. But she hesitated, unsure once again of her own capabilities. To Willard she expressed her doubts: "I can't count on either yours [exhibition] or his [Hatfield's] until I see how my work goes. I can't paint just to paint a show and so much has happened to my insides since November."[26]

At least she now had a studio in the Los Angeles house, and her art supplies had finally arrived from New Mexico. She set out to work in an initial "fever of energy and pleasure," but the momentum soon failed. In mid-February she wrote Willard, "I am in a stupor of creative inertia, if there is such a thing. I go to bed at night thinking 'tomorrow it will take form' but each day goes by empty. I do not understand what is happening and I feel tired and miserable most of the time."[27]

Her creative energies were at a low ebb, and she felt helpless to do anything about it. Part of the difficulty was in the increased demands on her time. The war called for sacrifices on everyone's part, and she was willing to make them—eager, in

Figure 23. Ernest Knee photographing on the California coastline, c. 1943. Photographer unknown. Collection of Eric Knee. Photo courtesy Eric Knee.

fact, to feel a part of the war effort. Ernie now had a job in the Howard Hughes Aircraft Company in Culver City. Working closely with the eccentric, reclusive "Pappy" Hughes, he photographed test airplanes, armaments and, sometimes, the Hollywood starlets Hughes befriended (fig. 23). Gina modified her schedule to suit the demands of her husband's. They rose early, she prepared his breakfast and packed his lunch, and then she drove him to work in the pre-dawn rushing traffic. Returning home, she faced the tasks of managing the household without help.

Gina's affluent upbringing and the ease of finding servants in Santa Fe had accustomed her to hours of time spent as she chose. In wartime Los Angeles, when servants were impossible to find, she suddenly had to do everything, and it soon began to feel burdensome. Dishwashing, making beds, dusting, laundry—all the things middle-class women took for granted in the 1940s—were frustrating and time-consuming. "It just takes hours for me to do what an organized housewife does in

one," she complained.[28] Even cooking, the one domestic activity she had always enjoyed, became a chore when combined with everything else. After finally getting into her studio to paint during the afternoon hours, she struggled to shift into her imaginative realm. Then, too soon, it would be time to stop, to exchange brushes for kitchen utensils. Often it was difficult to make the abrupt mental shift during the few steps from studio to stove. "Several days . . . when I came up to cook supper I was so out of the world or something that I burnt things and spilled things and made a domestic mess. Emotional and vegetable."[29]

Forced to sacrifice precious studio time to the demands of a repetitive household routine, she came face to face with a new reality: that she must now give up a certain amount of control over her life. Money, her own independent income, formerly had given her the luxury of time—time to be used as a man does, in professional activity, freed from enervating household chores. Unlike many women artists, Gina had not contended with the tedium of women's lives, juggling domestic responsibilities and professional demands. Now the leveling effect of the war reminded her firmly that she was a woman, in a situation in which affluence could not buy the uninterrupted freedom to create. Her life was turned upside down, her priorities questioned, her relationship with Ernie strained. Where his direction was clear, his involvement with the great war effort stimulating, her professional direction felt muddled. Again she turned to Marian Willard:

> I am afraid that I resent the labor part of my days because Ernie is so happy and enthusiastic and content in his. Do you see what I mean? He was so desperate in Santa Fe and I was strong there and controlled. Here I am either in a vacuum of self pity—where degrading thoughts about how I am turning into a slave torment me, where time seems to be rushing past me or I am upbraiding

myself for self pity and wondering where my guts are.[30]

Willard recognized at once the desperation in Gina's letters. She could picture her friend, standing alone at the studio window, listening to the gun salutes and taps of daily burials at the vast military cemetery just beyond the Knees' house. Willard knew at first hand the war's devastating effects on artists everywhere. She replied to Gina, "I am glad you told me your state of mind. It reflects the struggle that each individual creative person is having with himself in the world today." They agreed to postpone Gina's Willard Gallery exhibition until, as the dealer wrote, "the flow and desire to work return to you."[31]

But Willard wrote too of hope in the early spring of 1943. She believed that the war momentum was shifting and that spiritual renewal in art would be one of its eventual outcomes. "The tide is turning," she added, "slowly and as inevitably as the sea." She spoke of the need for artists to "seek strength from each other. Our deep faith is being tested and I am sure that we will survive and with it bring out a new life that has barely been tapped, that holds great energy for us."[32]

Willard also knew that Knee was extremely sensitive to her environment. The artist had thrived in the high desert of northern New Mexico, with its stark mountain silhouettes, chiseled canyons, and piñon-dotted mesas. Willard, who had no special fondness for Los Angeles, believed that Gina's creative impasse stemmed in part from the wrenching move from New Mexico: "Your [struggle] has been aggravated by the fact that you had to leave the hills that nourished you for the flat souless suburbs of L. A., the place where people live horizontally."[33] People lived on the surface there, she meant; its soil discouraged deep roots.

The winter rains dampened Gina's mood further. On wet days her unheated studio was too cold to use, and she suffered as much from the inactivity as from the gray skies. She

thought briefly of fleeing to New York but realized that things would probably be no better there. Besides, she would hate herself for running away from what she judged to be her own inadequacy. She considered getting a defense job, busying herself with something that would wrap her in daily activity and exhaust her enough to sleep at night. Still, even as she lay awake considering what to do, one thought burned clearly through the confusion. She knew she must not abandon that life-sustaining activity of making art. It was her only certain spiritual refuge, and Marian was the only person she could count on to understand that: "If I fling myself into a defense job and get into the fever of the life which I see people so alive and alert in, I will know that I have traded something I hold dearer than life for that mess of porrage [*sic*]—because I must create a living thing in life from life, not a series of busy interesting days."[34]

As life was eroded by the pounding waves of war, she clung more desperately to the scrap of precious turf defined by her art. Her painting was her sanity as well as her strength. "The war, the agony of the world, the ever present consciousness of it must not weaken me," she determined.[35] She took inspiration from another of Willard's artists, Morris Graves, who had waged a long battle with the government over his antiwar views. Marian reported that after months of clinging to his principles and refusing through passive resistance to cooperate with the military, Graves finally was released from the stockade and granted an honorable discharge. Willard encouraged Gina to take heart, to tap into the collective spiritual strength of principled individuals everywhere, and to hold on to "an invisible thread between us that can make all the difference."[36]

Then, abruptly, the dark veil of her depression lifted. Gina wired Marian on March 20 that a "sudden metamorphosis" had her working again. She wanted to reinstate plans for the canceled April show. Willard wired back a response, then fol-

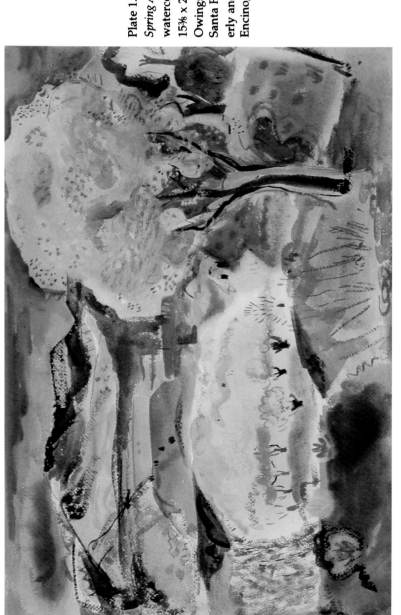

Plate 1. Gina Knee, *Tesuque Spring Apple Trees*, 1940, watercolor on paper, 15⅜ x 22½ in. Formerly, Owings-Dewey Fine Art, Santa Fe; collection of Beverly and Felix Grossman, Encino, California.

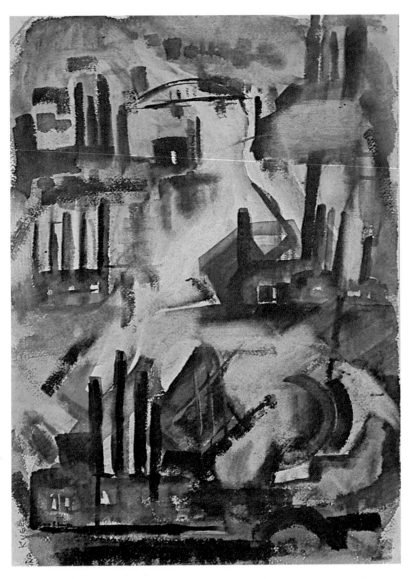

Plate 2. Gina Knee, *Near Pittsburgh*, 1935, watercolor on paper, 21 x 15 in.
Current location unknown. Photo courtesy Skidmore College Art Gallery.

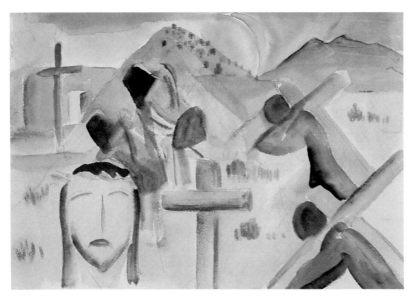

Plate 3. Gina Knee, *Penitente*, mid-1930s, watercolor on paper, 13⅜ x 20⅜ in. Private collection; photo courtesy Owings-Dewey Fine Art, Santa Fe.

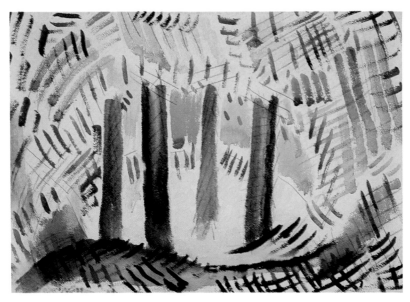

Plate 4. Gina Knee, *Indian Tree Fantasy*, 1938, pencil and watercolor on paper, 14½ x 20½ in. Photo courtesy Owings-Dewey Fine Art, Santa Fe.

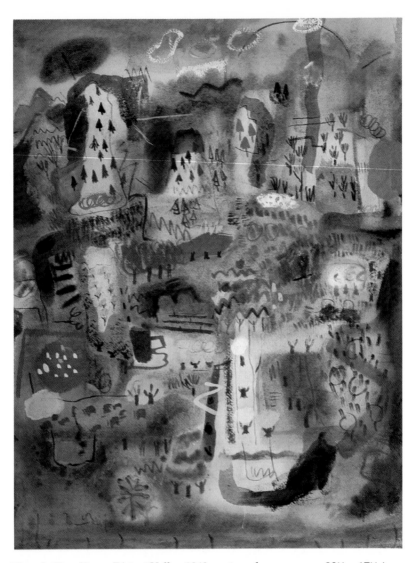

Plate 5. Gina Knee, *Distant Valley*, 1942, watercolor on paper, 23½ x 17½ in.
Photo courtesy Owings-Dewey Fine Art and the Gerald Peters Gallery,
Santa Fe.

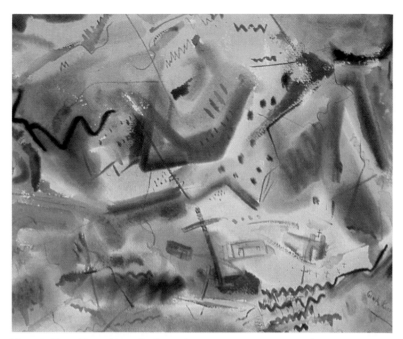

Plate 6. Gina Knee, *Near Cordova, New Mexico,* 1943, watercolor on paper, 19 x 23 in. The Anschutz Collection.

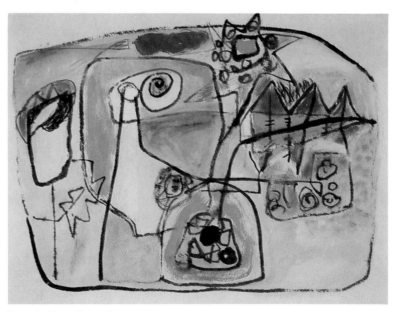

Plate 7. Gina Knee, *Abstraction,* c. 1943, watercolor on paper, 12 x 16 in. Photo courtesy Owings-Dewey Fine Art, Santa Fe.

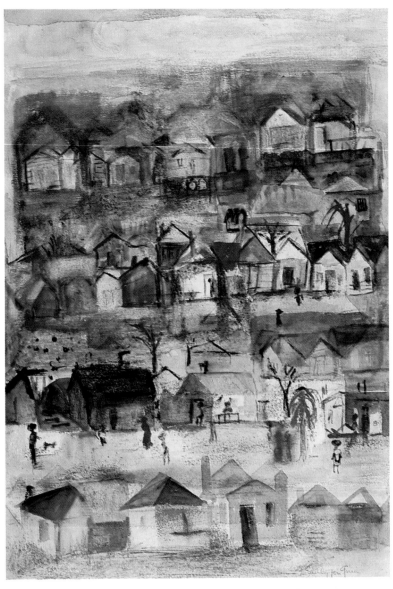

Plate 8. Gina Knee, *Houses on a Hillside*, c. 1946-7, watercolor on paper, 19⅛ x 13½ in. Photo courtesy Owings-Dewey Fine Art, Santa Fe.

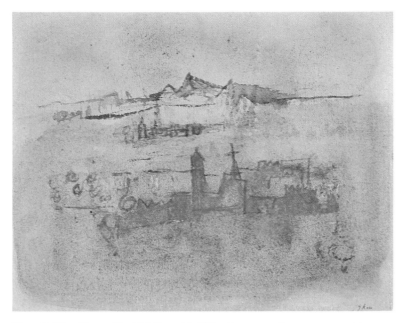

Plate 9. Gina Knee, *Untitled* (*Spanish Village*), watercolor on paper, 4½ x 6 in. Photo courtesy Owings-Dewey Fine Art, Santa Fe.

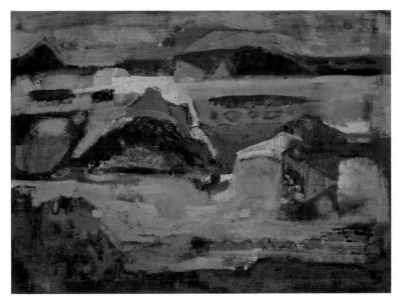

Plate 10. Gina Knee, *Caldera*, 1959, gouache on paper, 21¼ x 30 in. Photo courtesy Owings-Dewey Fine Art, Santa Fe.

Plate 11. Gina Knee, *Puma and Pine Tree* (*Christmas Composition*), watercolor on paper, 10½ x 16⅜ in. Photo courtesy Owings-Dewey Fine Art, Santa Fe.

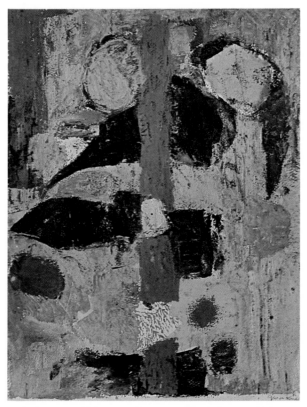

Plate 12. Gina Knee, *Spanish Images*, 1965, tempera, 20 x 26 in. Photo courtesy Skidmore College.

lowed with a letter of explanation. She was delighted at the "metamorphosis": "It was so good to hear that you have broken through that dark period and have started in again . . . I hope that you strike a deep rich vein." Unfortunately, it was too late to reinstate the April show; she had scheduled a David Smith sculpture show and an exhibition of prints by Stanley William Hayter in the empty weeks, but she proposed that Gina's show head off the fall season at the gallery.

Meanwhile, Knee still had the Hatfield show, scheduled for June. In a flood of creative energy, she burst out of the dark months of inactivity. It was clear almost at once that even during the period of blocked creativity she had been absorbing moods and motives from the California environment. Perhaps the transition from New Mexico had been painful, but now she began to find the pulse of California. Its life forms, its weather, its closeness to the sea—all were there to be explored in new paintings.

California watercolor painting was especially vigorous during the 1930s and 1940s, with such artists as Millard Sheets, Milford Zornes, George Post, and Dong Kingman active in the medium. Annual watercolor exhibitions were held at the Los Angeles Art Museum and at the Oakland Art Gallery, shows at which eastern artists such as Charles Burchfield and Andrew Wyeth exhibited. Gina Knee had exhibited in the Los Angeles show while she still lived in New Mexico, winning prizes in 1938 and 1939. Now she joined the California Watercolor Society and would participate in major West Coast shows for the next several years. Along with many other California watercolorists she exhibited in the annual international watercolor exhibitions at the Art Institute of Chicago, an event first organized in the 1920s. Through these major shows American watercolors gained stature worldwide, building on the foundations laid by Winslow Homer and John Marin. Californians were proud of their participation in the growth of an American watercolor tradition.

In that era of regionalist painting, California watercolorists built their paintings around the impressive scenery and magnificent climate within easy reach. For the most part they eschewed the social realism practiced elsewhere in the country in favor of a broader American Scene regionalism. They developed a "California Style," which emphasized the natural beauty and landscape majesty of their state, taking advantage of the light and sunshine available much of the year. Often there was a prevalence of vibrant color—warmer, higher in key than the more somber colors used by their eastern counterparts. Californians often painted directly onto the paper with little or no preparatory pencil drawing (a practice Knee had already adopted) and used wet paint on wet paper, sometimes allowing the white paper to show through to achieve certain effects. Where Gina Knee differed with most California regionalists was in her preference for sensitive improvisations based on nature rather than on their typically greater fidelity to the landscape motif.

Seeing the work of other innovative watercolorists inspired Gina to get out of doors, to explore nearby beaches, to collect the detritus of nature. As she had once gathered animal bones in the high desert of New Mexico, she now found fish skeletons, shells, nests, driftwood, and sand on southern California beaches. New Mexico friends such as Spud Johnson, who had heard her earlier complaints about the oppressively "horizontal" life in Los Angeles, now began to see a rebirth of nature in Gina's work. Johnson responded in poetry to her new California paintings:

> The strangely water-chiseled wood
> You find upon the beach,
> Bone-white, chocolate, mauve,
> Dove-grey and old-cheese green;
> These have become a language for you to say,
> And for us to hear by seeing,

How ugly is the furniture
How less than gay the flowers that have no scent,
The fruit that has no taste.
The strangely chiseled forms are dream-sculpture,
Expressing the out of kilter;
But the colors and shapes,
When you arrange them,
Put everything, suddenly,
And aren't you glad?
In focus again—in kilter—in place.[37]

"For us to hear by seeing" suggests Johnson's shared affinity for the sensory overlap Gina's paintings explored. And his last lines recount the healing, centering power of art for both its maker and its audience.

Walking the California beaches, Gina considered the tiny organisms held captive by surface tension within a drop of ocean water. She wandered inland to seek the promise of life under the mud of a dry lake bed. Creatures living or dead, seen or imagined, were the visible embodiment of cycles of life. A regular repeating curve might suggest the flashing arc of a fish's tail, the meander of a snake's path in the sand, the slow slide of a muddy river. Branching patterns of fishbones rhymed with leaf structures or the delicate configuration of a feather. In paintings such as *Beach Scene,* 1942 (fig. 24), she suspends the creatures of the sea in a primal, watery world.

Knee's was not a contrived, analytical study, not an attempt to fit natural phenomena into the grid of creation. In her paintings she explored the precision of a spiral mollusk shell, but she understood too the randomly ordered chaos of the larger undersea environment. Hers was a natural, relational observance based on sensitivity to her environment. She felt keenly the interrelationship of life forms in a world made more fragile by the cataclysm of war.

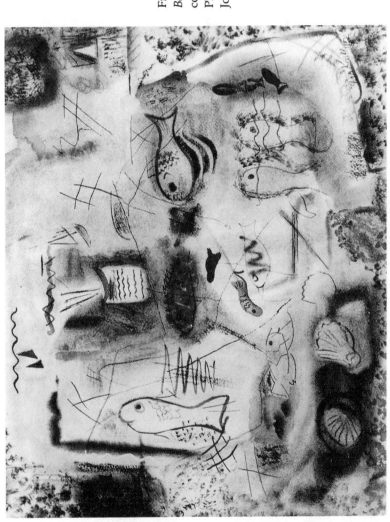

Figure 24. Gina Knee, *Beach Scene*, 1942, watercolor on paper, 20 x 23 in. Photo courtesy Miani Johnson.

Figure 25. Gina Knee, *Little Fish in a Big Sea*, 1943, watercolor on paper. Photo courtesy Miani Johnson.

The war affected her on both personal and global levels. Her own uprooting from a place that had nourished her creativity made her more keenly aware of the vulnerability of all human beings. In her art of the 1940s this theme began to play a major part. She linked the experience of simple creatures to the subtle complexities of human life, finding tragedy or heroism in the smallest events of existence. In a romantic way she looked for direction, healing, and spirit in the natural world. She would have agreed with Thomas Hardy's well-known personification of nature:

> *When I took forth at dawning, pool,*
> *Field, flock, and lonely tree,*
> *All seem to gaze at me*
> *Like chastened children sitting silent in a school.*

When Gina projected her own feelings onto the natural world, the results in her paintings were sometimes obvious, sometimes more subtle. *Little Fish in a Big Sea,* 1943 (fig. 25), is another of her California paintings, but one with a more pointed reference to human existence than *Beach Scene.* With a nod to the fantasy world evoked by Paul Klee's well-known *Fish Magic* (1925), Knee's composition moves beyond Klee's delicacy to a more sinister visual metaphor. By its title and by its dark, aggressive linear structure, *Little Fish in a Big Sea* seems to suggest Knee's wartime feelings of displacement within the teeming human pool of Los Angeles. Nature offered a mirror of self-recognition, a glimpse of meaning in a world devoid of meaning.

Carl Jung's writings acknowledge a primal need for "flight and fancy," the ability to step outside our usual frame of reference to find new wisdom, new truths. Knee's painting *Mardi Gras,* 1943 (fig. 26), acknowledges the fanciful adoption of anonymity through the donning of masks; it is a flight from the quotidian into the contrived gaiety of carnival. But connections beyond those to human society beckon her brush: In

Figure 26. Gina Knee, *Mardi Gras*, 1943, watercolor on paper. Photo courtesy Miani Johnson.

her paintings Knee seeks the primal world of plants and animals, a realm once revered in some long-forgotten prehistory as the repository of truth beyond logic, language, or conscious thought. Ancient human beings looked to nature for their deepest sources of wisdom. Perhaps even now, as Stanley Kunitz argues, a kind of body wisdom from the "old brain" resides in each of us—the source of poetry and of art.[38] Is there a part of the human cellular structure that retains a vestigial memory for these connections?

Gina Knee clearly felt a personal connectedness to the cycles of plant and animal life, to the primal mysteries of human consciousness. In *World of the Nest*, 1943 (fig. 27), she creates an encircling refuge for three tiny birds. It is tempting to equate the nest with Gina's vanished dream of domesticity:

Figure 27. Gina Knee, *World of the Nest*, 1943, watercolor on paper. Photo courtesy Miani Johnson.

her longed-for New Mexico home and the child she could not have. It would be easy to fall into an essentialist trap of calling the spaces of these paintings female. To do so would do an injustice to their formal conception and squeeze the artist into a stereotype of the feminine that is, at best, an uneasy fit. Knee's 1943 paintings reflect instead what Annette Kolodny has called "a complex figure of adaption and interdependence between the human and natural."[39] In the broadest sense, they allowed the artist to act and, literally, to shape the world while

at the same time nurturing and sheltering life within the confines of paper or canvas.

But this need not preclude a poetic interpretation of Gina Knee's spaces; she frequently thought and wrote in decidedly poetic terms. The nest, as philosopher Gaston Bachelard argues in *The Poetics of Space*, is indeed a poetic metaphor for the house but is most evocative of the concept of return:

> Not only do we *come back* to [the nest-house], but we dream of coming back to it, the way a bird comes back to its nest, or a lamb to the fold. This sign of *return* marks an infinite number of daydreams, for the reason that human returning takes place in the great rhythm of human life, a rhythm that reaches back across the years and, through the dream, combats all absence.[40]

With her interest in Jungian imagery, it seems safe to assume that Gina Knee would assent to Bachelard's linkage of house and nest. She consciously looked across boundaries of culture and artistic media for repeated images that reveal the common preoccupations of her era.

Especially during these California years, her artistic vocabulary embraced the telling visual metaphor. *Seed Pods Never Die*, 1943 (fig. 28), is another of her romanticized extractions from nature—simple, earnest, cliched. Probably Gina did not know the Zen saying "No seed ever sees the flower," but she intuited its meaning in her painting: Death in some form must precede rebirth and growth. Here is imagery that marries idea and feeling in intimate embrace with the flow of life. Such ideas often have emerged in the words and imagery of artistic women. Anaïs Nin, for example, also identified with the ritual and mystery of nature's cycles: "The art of woman must be born in the womb-cells of the mind. . . . I must install myself inside of the seed, growth, mysteries . . . art must be like a miracle. . . . It must be for woman, more like a personi-

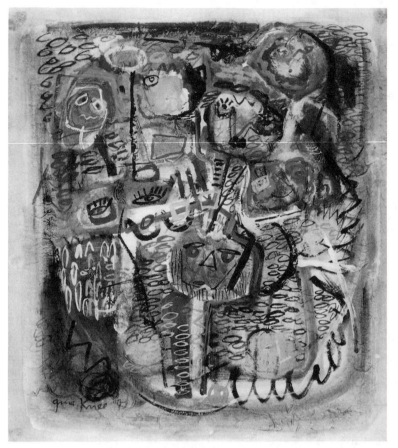

Figure 28. Gina Knee, *Seed Pods Never Die*, 1943, watercolor and gouache on paper. Photo courtesy Miani Johnson.

fied ancient ritual, where every spiritual thought was made visible, enacted, represented."[41]

Gina must have felt like a person reborn during the spring of 1943. Released from the deathlike dormancy of her winter depression, she marveled at her own surge of creative energies. Daily, new ideas pushed their way into her consciousness and from there onto her watercolor paper. Even during the darkness of her spiritual night, the germ of new paintings had been incubating. In the spring warmth of her studio they were ready to be born. *Seeds and Roots, Growth of a Pear, World*

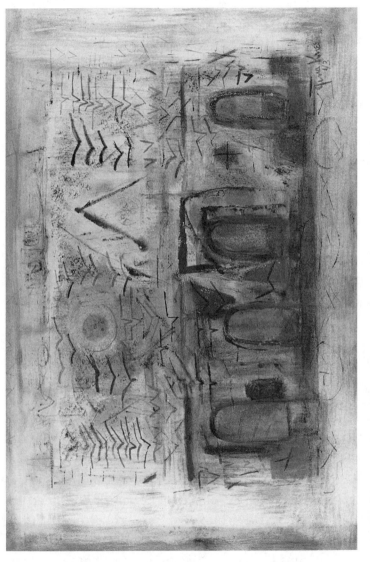

Figure 29. Gina Knee, *Swallows Return to Capistrano*, 1943, watercolor on paper, 14 x 21 in. Santa Barbara Museum of Art, 1943.4.1.

of the Nest, Swallows Return to Capistrano, 1943 (fig. 29)—all are metaphors of rebirth, of finding oneself again.

Matching materials and technique to imagery, Knee produced in *Seeds and Roots* (now in the Phillips Collection, Washington) a dense composition of multiple images and an internal, cell-like structure. Working in gouache, she built up enriched, tapestrylike surfaces with visible texture. She wanted to burrow beneath the skin of nature, penetrating to the hidden heart of the seed where life begins. By magnifying the mysteries of small forms she creates an effective strategy for viewing the microcosm. There is an appealing innocence to these paintings, even if the imagery occasionally becomes repetitive in its insistence on nature as reservoir of subjective feeling. What saves the work is its balance of natural and artistic experience. There is stylistic variation: some of the watercolors are delicately nuanced, lyrical; others are dense with structural incident. Whatever the mood, vision and structure are inseparable.

As the time for her show at the Hatfield Gallery approached, Knee worked in a sustained fever to complete twenty paintings. "The spirit is much more in tune now; in fact it soars some days," she wrote to Marian Willard.[42] Though she worried over the usual things—framing, lighting, wall arrangement—the difficulties were resolved by June 1. Hatfield gave a gala opening, attended by many artists and celebrities, perhaps 150 people in all. Gina was especially gratified to have a number of artists at the opening.

Collector Walter Arensberg, who later acquired one of the paintings, told her at the opening that the paintings opened up a wonderful new world to him. Longtime collectors of European and American art, Walter and Louise Arensberg were hosts and patrons to a circle of avant garde painters at their New York apartment during the 1910s. Their home became a frequent gathering place for young poets and artists, whose paintings the Arensbergs often purchased. And the irreverent

New York Dada movement flourished for a few years inside and outside the walls of the West Sixty-seventh Street flat. Walter Arensberg, in addition to purchasing some of the finest pieces of the period, also supported "little magazines," lectures, and other literary endeavors. There was considerable crossover between the Arensberg circle and that of Alfred Stieglitz, the other great New York patron of the American avant garde. William Carlos Williams, Marcel Duchamp, and Man Ray were among the frequent guests at the Arensbergs; the latter two continued their close association with the collectors even after the Arensbergs moved to southern California in 1921.

The move, they said, was necessary to stem the eighteen-hour daily commotion in their home.[43] They packed up their huge art collection and moved abruptly to Hollywood. Though their relocation removed them from the storm center of the New York avant garde, they continued to collect art and soon established an active presence in artistic circles of southern California.

It was important for Gina Knee to have her work enter the Arensberg collection. Walter Arensberg was a collector whose taste required that art provide intellectual as well as aesthetic stimulation. His collection, much of which is now at the Philadelphia Museum of Art, is not so much a group of stylistically related pieces as a collection of highly individualized works, each of which captured the attention of this intelligent, esoteric collector. He had encouraged many artists and writers to use their imagination freely and exuberantly; now he saw and praised that quality in Gina Knee.

Hatfield was skilled at securing publicity, and he saw to it that her show received wide notice. Gina was interviewed for a radio program called "Women Make the News" and was pleased, as she wrote Willard, that the show reported her statements accurately. Well-known critic Arthur Mellier, who seldom praised abstract painting, compared her watercolors

to the delicate, evanescent music of Claude Debussy but granted them firmness and strength as well: "There are rich colors which consort nicely and smokey tones and rubbed textures and firm wandering lines that create satisfactory esthetic effects—something like Paul Klee but less eerie."[44]

Donald Bear, who had curated the 1939 New York World's Fair exhibition and had given Gina a show at the Denver Art Museum, wrote a statement for the Hatfield brochure. He spoke of the dreamlike quality of her paintings—their vitality, their metaphysicality. He was reminded of Odilon Redon, who, it was said, painted flowers after they died in the hope of capturing their souls. "Gina Knee," he concluded, "compels the eye to take in, realize and register both emotionally and intellectually more than it can actually focus upon in nature. She imparts to the spectator the excitement of being in the center of things. Her landscapes recreate the miracle of a dream."[45] Bear, by then director of the Santa Barbara Museum of Art, invited the show to travel there. It also went on to the San Francisco Museum of Art in September, coming down in time for transport to the Willard Gallery show in November.

Since a number of paintings were sold from the show, Gina worked through the summer to complete more. The André Masson drawings encouraged free, spontaneous compositions; her painting *Ballet of Creatures* is an orchestration of biomorphic forms, spare but firmer than Masson's linear work. The strength of pre-Columbian sculpture she saw in galleries and private collections also inspired her. To Willard she wrote, "I wish you could see the pre-Columbian things here— they are so beautiful."[46] She made a painting she titled *Pre-Columbian* for inclusion in the New York show.

Busy as she was, Knee made time for some war work. Six months earlier she could scarcely cope with a day's household tasks, but now that her emotional equilibrium was restored she had the energy both to paint and to give time to others. Twice a week she drove to the naval hospital at Long Beach to

work in the wards with the wounded men. "I am getting them interested in painting," she wrote Willard, "not trying to teach but just letting them pass the time (apparently) while actually spreading the art gospel." She hoped that art could be for these men what it had become for her: cathartic, healing. If it began as a mere diversion, fine. The men started by leafing casually through books of paintings, sometimes pausing to study one. Then they began to say what they liked about certain ones. Eventually they asked for paints and brushes and began to record their own feelings and experiences. Gina wrote with emotion of a young injured soldier who started by painting bright flowers and open fields, then moved on to painting battlefields and cemeteries—places he had been but couldn't talk about in words. As Gina saw his pain come out on paper, she recognized again the therapeutic power of art. "I could go on and on about those experiences," she told Willard, "and they are really doing as much for me, almost more, than for the men." [47]

Working steadily through the summer at her own painting, she completed enough watercolors for the New York show. They were paintings more consistent in style and feeling than she had ever exhibited before. Central to the group of paintings was Knee's further exploration of the elusive, mystical qualities she experienced in nature. *Valley of the Gods, Morning Star, Cliff Wall,* and *Mirage* convey nature's asperities; *Mobile Stones, Dance for Rain, Fetishes, Ballet of Creatures,* and *Jungle* speak of the animism she found there.

Knee felt an organic resonance with her surroundings. Never reducing nature to scenery, she could sense the mysteries immanent in it. Paintings such as Growth of a Pear, Quiet Life *of a Bird's Egg,* and World *of the Nest* come close to suspending time; nature will not be rushed. On the clock of eternity a single season is no more than a millisecond. Contemplation, quietude, nearly imperceptible growth—these are the components of Knee's 1943 work. Decided abstraction freed forms

from unnecessary ties to objective referents; Knee was aiming for integration of color and tonal mood, visual metaphors for the integration of the natural world.

These paintings affirm that humanity is related to and dependent upon innumerable other life forms, extending in a web of connection to every living thing throughout the world. By this standard, what happens within the confines of a bird's nest is inseparable from and no less significant than any spectacle staged by human beings. In her fascination with growth and function in nature, the artist saw the living record of the past. She apprehended that ancient biological and geological events placed humanity on a continuum with all life. Without conscious perception of it, Knee was drawing on the ancient belief that the natural world is composed of a myriad of living patterns—that life arose from some primordial, undifferentiated substance.

Though Gina Knee was attuned to both biology and the poetics of nature, we must not conclude that the artist was naive or out of touch with the present. This sophisticated and widely read woman was in fact in tune with a modernist sensibility that rejected the Victorian separation of "higher" rational faculties from the "lower" instinctual ones. In thinking that emanated from William James and John Dewey, this view held that the mind must be thought of as functionally integrated and that human beings exist on a continuum with other animals. To all beings, human and otherwise, initial, raw sensory experience is the closest approach to reality. The intellect, argued James, only removes us further from the "truth."[48]

Gina Knee chose this path—of continuity, of linkages, of merger with natural processes. These are the principles, congruent with her imagination and her learning, that underlie her painting. Out of them flows the contemporary global recognition that all life forms must share the planet and its resources.

She strove to make her paintings, like her thought, at once universal and intensely personal. Formally rich and inventive, they evoke Bachelard's spaces of "intimate immensity" in which substances, shapes, and textures represent elemental processes. Placing the specific within the vast continuum of life helped Gina keep things in perspective, or perhaps to substitute an imaginary realm for a reality too painful to contemplate: Even the horror of war seemed finite within an endless expanse of geologic time.

Meanwhile, another painful reality began to make itself felt. Whether coincidentally or not, there were signs that the Knees' marriage had begun to crumble. Strains on the delicate fibers of their relationship were many: Ernie was younger, stimulated by his job on the fringes of the Hollywood scene, eager to pursue life's possibilities at a time when his wife longed for respite from a frenzied world. Gina had always known that marriage to a younger man held certain risks. Now, in her mid-forties, she had given up hope for the children who might solidify the marriage, and she sensed his restlessness. Ernie's detached support of her painting began to seem like real indifference. To Spud Johnson she confided, "I find my life with Ernie alive and full when we are together but because he cares little for the communication of words—there is a lapse of reality when we are apart."[49] The apartness became more and more frequent. Ernie had, in fact, met an attractive younger woman at the aircraft plant and had begun a relationship with her.

Convinced that their marriage was over, Gina returned to New Mexico in the fall of 1943. To friends there she confided her sense of loss and sorrow. To Marian Willard she wrote simply, "It has been terrible and I am feeling tired and low."[50]

With great effort, she struggled to fulfill her commitment for the November show in New York. In the last frantic days before leaving Los Angeles she shipped off twenty-four paintings to Willard, unable in her confused state of mind to select

the fifteen needed for the show. "I was in such an emotional stew that I couldn't have [made] a choice anyway," she explained to Willard. "They all seemed terrible."[51] The paintings she started with such bright promise in the spring now were tainted by doubt and despair. As always, her art and life were inseparable. She felt fragile, wispy, adrift.

But New York critics saw and praised a consistent emotional tone in her paintings. They pointed out in the 1943 work a measurable development beyond her work of the previous year. The *Art News* reviewer noted "a modest, subjective quality to these gracious abstractions. The artist's restraint is such that the most violent of her pictures is entitled The *Quiet Life of a Bird's Egg.*"[52]

Notes

1. Gina Knee to Marian Willard, 9 Dec. 1941, WGP.

2. Gina Knee, cited in Sidney Janis, *Abstract and Surrealist Art in America* (New York: Reynal & Hitchcock, 1944), 98.

3. George P. Landow, *William Holman Hunt and Typological Symbolism* (New Haven: Yale University Press, 1979), 80.

4. Gina Knee to Marian Willard, n.d. [Feb.–Mar. 1942], WGP.

5. Ibid.

6. Ibid.

7. Spud Johnson, "Impressions of Some Watercolors by Gina Knee," *New Mexico Quarterly Review* 12 (1942): 301–3.

8. Gina Knee to Marian Willard, n.d. [Feb. or Mar. 1942], WGP.

9. One of the most prominent statements of this thinking is Roland Barthes's essay "The Death of the Author," in *Image, Music, Text*, trans. Stephen Heath (New York: Fontana/Collins, 1977), 143–48.

10. Ibid., 5.

11. Gina Knee to Marian Willard, 31 Mar. 1942, WGP.

12. Ibid.

13. Unsigned review, *New York Herald Tribune*, 12 Apr. 1942.

14. Howard Devree, "A Reviewer's Notebook," *New York Times*, 12 Apr. 1942, X5.

15. J. W. L., review, *Art News* 41 (1 May 1942): 34.

16. Unsigned review, *Art Digest* (15 Apr. 1942): 31.

17. Duncan Phillips to Marian Willard, 11 June 1942, WGP.

18. Lawlor Cohen, "Duncan Phillips," *France* 19 (Summer 1991): 13.

19. Marian Willard, cited in Judy K. C. Van Wagner, *Women Shaping Art* (New York: Praeger, 1984), 33–34.

20. Alfred Morang, review, *Art Digest* (1 Oct. 1942): n.p.

21. Calla Hay, "Gina Knee's Exhibit Opens at White Gallery Monday; Travels to UNM and West Coast Later," *Santa Fe New Mexican*, 15 Oct. 1942, 3.

22. Gina Knee to Marian Willard, 22 Dec. 1942, WGP.

23. Ibid.

24. Gina Knee to Marian Willard, 2 Jan. 1943, WGP.

25. Gina Knee to Marian Willard, 30 Mar. 1943, WGP.

26. Gina Knee to Marian Willard, 2 Jan. 1943, WGP.

27. Gina Knee to Marian Willard, Feb. 1943, WGP.

28. Ibid.

29. Ibid.

30. Gina Knee to Marian Willard, Feb. 1943, WGP.

31. Marian Willard to Gina Knee, 13 Mar. 1943, WGP.

32. Ibid.

33. Ibid.

34. Gina Knee to Marian Willard, Feb. 1943, WGP.

35. Ibid.

36 Marian Willard to Gina Knee, 13 Mar. 1943, WGP.

37. Spud Johnson, "First Draft of a Poem for Gina," n.d. Spud Johnson Papers, Harry Ransom Humanities Research Center, University of Texas at Austin.

38. Stanley Kunitz, *Next-to-Last Things: New Poems and Essays* (Boston: Atlantic Monthly Press, 1985), 51. I am grateful to Margaret Nathe for this reference.

39. Annette Kolodny, quoted in Lois Rudnick, "Re-Naming the Land," in *The Desert is No Lady: Southwestern Landscapes in Women's Writing and Art*, ed. Vera Norwood and Janice Monk (New Haven: Yale University Press, 1987): 26.

40. Gaston Bachelard, *The Poetics of Space* (New York: Beacon Press, 1969), 99; emphasis in original. Such thinking also relates to Eastern philosophy, to which artists such as Mark Tobey responded in the 1940s with works like his painting *The World Egg*, 1944.

41. Anaïs Nin, *The Diary of Anaïs Nin*, vol. 2 (New York: Harcourt, Brace & World, 1967), 234–35. Gaston Bachelard also thinks of seed pods as explicit images of transformation; see *Poetics*, 132–33.

42. Gina Knee to Marian Willard, June 1943, WGP.

43. William Innes Homer, *Alfred Stieglitz and the American Avant-Garde* (Boston: New York Graphic Society, 1977), 185.

44. Arthur Mellier, "Knee Works Have Charm That Eludes," undated clipping from Knee file, WGP.

45. Donald Bear, cited in *Gina Knee—Watercolors* (Los Angeles: Dalzell Hatfield Galleries, 1943), n.p.

46. Gina Knee to Marian Willard, 30 Aug. 1943, WGP.

47. Ibid.

48. See Daniel Joseph Singal, "Towards a Definition of American Modernism," *American Quarterly* 39, No. 1 (Spring 1987): 7–26.

49. Gina Knee to Spud Johnson, n.d. [1943], Johnson Papers.

50. Gina Knee to Marian Willard, 19 Oct. 1943, WGP.

51. Ibid.

52 Review, *Art News* 42, no. 23 (15 Nov. 1943): 23.

3

LATER YEARS: NEW YORK

Knee spent much of the autumn of 1943 in New York. With Marian Willard she talked art, spirituality, and relationships. Once again, Willard proved a strong source of personal and professional encouragement, someone who could help her to see beyond the pain of the present. Gina spent time with old friends and met artists whose work she had long known. Perhaps it was during these months that she was introduced to the painter Alexander Brook. Or perhaps they met in Los Angeles, where he spent some winters in those years. Brook, a Brooklyn realist painter who trained under Kenneth Hayes Miller at the Art Students League, specialized early on in still lifes and female nudes but by the mid-1940s was better known for his oil portraits. Some of his well-known subjects were glamorous women of the Hollywood film industry: Ingrid Bergman, Bette Davis, and Merle Oberon, to name a few.

Active since the 1920s in the New York art scene, Brook had been a charter member of the Whitney Studio Club, organized by sculptor Gertrude Vanderbilt Whitney in 1918, and he participated in the club's annual Greenwich Village exhibitions during most of the 1920s. Under Juliana Force he worked as assistant director of the Whitney Studio Club between 1923 and 1927. (Force, who was interested in Gina Knee's work in the

1940s, was just one of their many mutual acquaintances.) Brook also wrote for art periodicals in the 1920s and had achieved a substantial reputation as a painter and sometime critic long before he met Gina Knee.

Brook had been married to the artist Peggy Bacon, whom he met when they both were studying at the Art Students League. They married in 1920, spent a year in Europe, and thereafter divided their time between the art colony at Woodstock, New York, and Greenwich Village. Their two children were born in 1921 and 1922.

Bacon was a thoroughly trained artist who specialized during the twenties and thirties in incisive, sometimes devastating caricatures of the colorful art-world figures of Woodstock and New York. In charcoal, pastel, and lithography she parodied artists, critics, dealers, and dilettantes with equal bite. Her prints and drawings were exhibited at New York's leading galleries: Stieglitz's Intimate Gallery, the Weyhe Gallery, and Edith Halpert's Downtown Gallery. But throughout her marriage to Brook, Bacon—despite her firm grounding in the medium—did not paint in oil. Self-confident, assertive, unwilling to take a back seat to most male artists, Bacon nonetheless bowed to her husband's opinion, which was that her paintings were inferior to the rest of her oeuvre. Reviewing his wife's work in 1923 Brook wrote, "In the beginning Peggy Bacon made terrible temperas which sold rapidly."[1]

As Bacon's biographer has noted, the force of Brook's personality convinced Bacon that his abilities and intuition for artistic expression exceeded her own. She was made to feel the inferior artist, and perhaps an inferior person as well. After twenty years the marriage ended in divorce. Looking back, Bacon later recalled, "I was shattered by our divorce. I felt humiliated. I had a very old fashioned attitude toward it. I felt I was a failure as a wife; I was really shattered. Then, of course, I realized I was much better off. I was without a cantankerous husband, which Alex had become terribly."[2]

To Gina Knee, Alex seemed strong, not cantankerous. She admired his gruff charm, his forthright opinions, and, not least, his artistic ability. Many years later she told a close friend that because of his skills as a painter "I was in love with Alex before I ever met him."[3] In those words lies a revealing glimpse of the relationship they would develop. Gina Knee, like Peggy Bacon, was sure that Brook's artistic sensibilities outstripped her own and was prepared from the outset to defer to his opinions.

Knee and Brook saw a great deal of each other in late 1943 and early 1944. When apart, he wrote her daily from New York and telephoned frequently. Her divorce from Ernie was final in April 1944; not long afterwards she and Brook began a new life together. To a friend, Gina confessed that with two failed marriages apiece, they were "both scared."[4] *Art Digest* reported their marriage in the same issue as that of Marian Willard, who was marrying for the first time. Publicly, Brook and Knee made light of their checkered marital histories: They told a reporter goodnaturedly that their multiple past marriages made for domestic harmony because it gave neither one advantage over the other.

The couple settled in Savannah, Georgia, setting up a studio home in an abandoned riverfront cotton warehouse (fig. 30). Alex had lived in Savannah on two previous occasions and had occupied the same building with his previous wife. Now, however, Alex and Gina made improvements in the huge space, turning two long rooms into their studios. Each opened onto the river and had north-facing skylights. Adjacent offices became living room, bedroom, kitchen, bath, and storage areas for paintings and supplies.

The couple did much of the work themselves. They opened long-closed fireplaces, scraped floors, painted walls, and built partitions. Alex, who enjoyed working with wood and carpenter's tools, attacked cornices, shutters, and cabinets with putty and wax, using the original fixtures whenever possible.

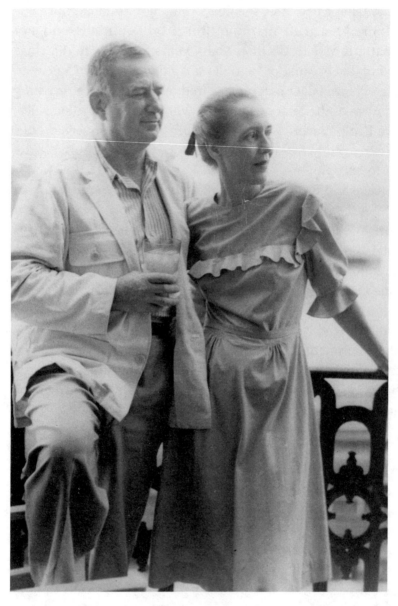

Figure 30. Gina Knee and Alexander Brook in Savannah, c. 1946. Photographer unknown. Photo, collection of the author.

Together they collected odd bits of bric-a-brac and turned it into studio decor. Two old iron washstands became flower stands. A shoemaker's last mounted on a wooden stand became a simple piece of sculpture.

Gina brought some pieces of her own to the studio, artifacts from her past homes in the West. From California came shells and a piece of smooth driftwood, polished by Pacific waves. Bleached animal bones from New Mexico, clean and elemental, reminded her of the desert's harsh beauty. A rugged wooden Penitente cross came to the studio too, an artifact from her paintings of the austere Catholic sect and an expression of her continuing interest in Hispanic and Indian folkways. Aesthetic objects related directly to the lives of their makers had always moved her, and she would continue to look for examples of authentic folk art wherever she lived.

Knee and Brook settled into a busy, productive time of painting in their Savannah cotton warehouse. In their adjacent studios they pursued their own visions—his the familiar realist portrait style that brought him continuing commissions, hers the highly abstracted response to nature she now began to adapt to the atmosphere, topography, and people of Georgia. She missed the Southwest, and Alex knew it. "The faraway look in her eye," he told a reporter, "is for New Mexico."[5] Writing to Spud Johnson in Taos after a silence of months, she explained, "Maybe it's easiest to say that in adjusting to a new life I had to cut the lovely strands of the past."[6] New Mexico had been the site of her greatest happiness, and she would always consider it her spiritual and artistic home. But life wrenched her from the Southwest to test once again her capacity for adaptation, for starting over.

On the surface, the Knee–Brook relationship was one of easygoing give and take, an equal partnership. But a marriage of professionals in the same field always piques speculation about power relations within the arrangement. Was there any rivalry? What kind of reciprocities or deference existed? Al-

though Knee and Brook had each been married to artists before, the scales were now weighted differently—at least for Gina. To a friend, Gina made light of the friendly power struggle, which she likened to their rides around Savannah on a tandem bicycle. Alex always sat in front, she reported, having "complete control and [the] decisions are all his."[7]

It had been different with Ernest Knee. Though a professional photographer, he had yet to gain much recognition as an artist during their marriage. Gina's independent income provided much of their support until Ernie moved into commercial photography during and after the war. (In the late 1940s he gave up photography for a woodworking business, returning only sporadically to the camera during his later years, when he began to achieve recognition for his early photographs.) He never interfered with and seldom commented on Gina's painting.

Alexander Brook, in contrast, was a solid professional, convinced of the rightness of his seeing and his style. He was accustomed to a wife who was not merely supportive but deferential. He assumed that his career would take precedence over hers. Not only that, he also dispensed advice and criticism freely, expecting that it would be heeded. Although he experimented with impressionistic effects in his early work and was fascinated in his student days with Picasso's and Braque's inventive abstractions, he retained a solidly realist orientation in his own work. Now he began to resent the extravagant attention the new generation of abstract painters received in the press and the galleries. Perhaps he saw that the artistic moment that gave birth to his style had passed. Though realist painting always would find an audience, it was entering a long phase of eclipse in the dawning era of Abstract Expressionism.

Gina occasionally chafed under the authoritarian attitudes of her new husband, yet for the most part she accepted his superior reputation and fixed opinions with good grace. Even

when Brook made a sketch of her that poked fun at both her independent spirit and her abstract painting style—he called it "an abstract painting of Gina letting off steam"—she good-naturedly tacked it to her bulletin board.[8] Still, she admitted to Marian Willard after a few years of marriage, "Even though I said I didn't care—the back seat has been pretty uncomfortable at times."[9]

Despite his occasional teasing, Brook was visibly proud of his new wife. In the early years of their marriage he helped her with details like framing and crating her paintings and encouraged her to submit them to juried exhibitions. He also appreciated her wit and charm, which endeared her immediately to his grown children and to his circle of friends, both in Savannah and New York. Brook painted Gina several times during the early years of their marriage. To the 1945 Corcoran Biennial he submitted a striking oil portrait showing her handsome profile. In hat, dark suit, and gloves, her chin slightly raised, she is every inch a distinguished woman, but in no visible way an artist. She resembles instead many of Brook's other sitters, well-to-do women of leisure. This was Brook's formal introduction of his new wife to the Eastern art establishment; significantly, he titled the painting "Gina Brook." Though she would use her new husband's name socially, she determined to retain "Gina Knee" as her professional name.

Knee's own work continued to grow and be exhibited. The introduction of her work to California audiences in 1943 had stimulated further exhibitions. In September 1945, the E. B. Crocker Art Gallery in Sacramento opened a four-person show of modernist-inclined painters: Gina Knee, Lionel Feininger, Mark Tobey, and Morris Graves. Probably Marian Willard, who showed all of them at her New York gallery, and collector Duncan Phillips, who admired them, were instrumental in arranging the Sacramento show. There were definite affinities among the four painters. Feininger's precise,

lyrical abstractions, with their carefully built up transparencies of planes, were spatially complex, as were those of Tobey, working in Seattle. But Tobey's labyrinthine "white writing" compositions explored space in a much denser, more intense fashion. Built up of nearly monotonic tracery, they seemed to have no beginning and no end, like energetically charged calligraphy. Graves, like Tobey, drew on Asian sources for his mystical interpretations of nature. And, like Gina Knee, Graves was acutely aware of humanity's oneness with nature. In his imagery of bird migration, for example, Graves explored humanity's restlessness and perpetual search for spirituality. Gina Knee's paintings, with their subtle abstraction and contemplative color, showed well with those of Feininger, Tobey, and Graves. The artists' overlapping orientations and attitudes created an exceptionally harmonious, unified conception for an exhibition.

Meanwhile, Gina's work in Savannah was subject to frequent interruptions: a trip to New Mexico to sell the Tesuque house, shipment of her furnishings to Georgia, and the long months of rebuilding and equipping the cotton warehouse studios. When the major work was completed and she could again concentrate on painting, she wrote Marian Willard, "It is awful to have been lost from work for such a long time but my personal life was in a constant state of change. Creative energies just disappeared." But by early 1946 she was busy "absorbing the Georgia Scene and working steadily."[10]

As she studied her new environment, Gina was struck by the cultural confluences of the South. She had been sensitive in New Mexico to the admixture of Anglo, Hispanic, and Native American lifeways. In particular she had appreciated the communal, balanced society of the Pueblos, whose serenity seemed born of their ancient links to the earth.

In Georgia the mix was different. She looked closely at the black population, whose history had also tied them, less happily, to the southern soil. She saw the joys and sorrows of their

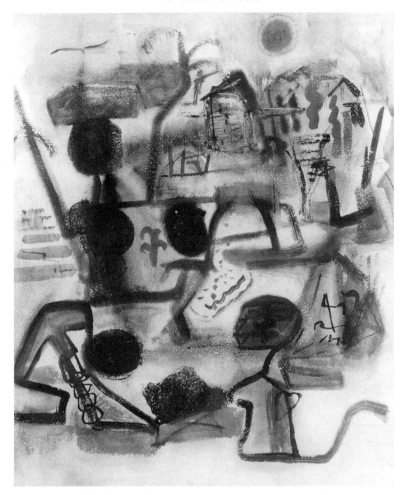

Figure 31. Gina Knee, *Lamentation*, 1946, watercolor on paper, 21 1/2 x 18 1/2 in. Photo courtesy Miani Johnson.

lives in Savannah and in the rural areas of Georgia. She talked to them, listened to their music on front porches and in clubs, heard the soft accents of their voices. In paintings like *Lamentation*, 1946, (fig. 31), she tried to to evoke the visual texture of the lives of southern blacks—bodies bent in attitudes of grief, heavy with the burden of work and sorrow. Not truly a landscape or a figure painting, *Lamentation* is a loose tangle of roof shapes, plant forms, low-blazing sun, and patches of culti-

vated earth—a melange of the textures, sounds, and smells of rural Georgia.

Later that year Knee ventured into new technical territory. For the first time she began to paint in oil, and it proved a decisive shift. In both the way she thought about and the way she executed her paintings, oil changed her art. Watercolor, which many artists consider more demanding, is an unforgiving medium. A stroke, once made, remains. Usually, watercolorists know in advance the effects they want to achieve; they must visualize how each addition will affect the whole. They must work rapidly before paper and pigment dry; mistakes are seldom correctible. Yet the watercolor medium has great advantages as well: fluid, versatile in the hands of a skilled painter, it encourages unity and spontaneity. For Gina Knee, watercolor had been liberating. Working wet on wet, she created very fluid passages, adding denser areas of pigment and solid or broken line to impose needed structure. Watercolor suited her talents for defining mood in terms of free, expressive color and form.

Now, however, she sought out the intricacies of oil. Perhaps remembering his heavy-handed suppression of Peggy Bacon's work, Alex encouraged Gina, knowing that the medium's density and slow drying would allow her to seek entirely new effects. Knowing that she could scrape off and repaint unsuccessful passages suggested new explorations of texture, color juxtapositions, and brushwork. In the big Savannah studio she began to work with the viscous new pigments, completing three paintings within a few weeks. She took them to New York in the fall of 1946, where she and Willard decided to make her next exhibition at least half oils. By January 1947 she wrote Willard, "I sincerely believe that I can arrive at the kind of thing I have been trying for in painting in the oil medium with more quality and meaning than in watercolors. In fact I do not feel in tune with watercolor painting at all now when I attempt it."[11]

But her early momentum in oil slowed when she discovered some of its pitfalls. She wanted to paint and repaint areas in hopes of improving them. Often, though, she overworked passages, muddying colors and leaving dead areas. It would take time to find her own approach to the demands of the new medium. Oil, she found, could be recalcitrant; it did not easily yield its secrets. Reluctantly, she decided to cancel a Willard Gallery exhibition planned for early 1947. She could not risk her reputation or self-esteem on half-realized paintings; she would wait until something authentic emerged in her oils.

Still fascinated by the South, she studied ways to evoke what she called the sometimes "sad or frantic" lives of blacks in Savannah.[12] *A Southern Sunday Afternoon*, 1947 (fig. 32), and Houses on a *Hillside*, c. 1946–47 (plate 8), are among these subjects. They are paintings about the texture of life in crowded southern neighborhoods, at once harsh and somehow gently communal, definitely antiheroic in conception and execution. Knee adapted her technique to the mood she wanted to generate. She built up layers of viscous pigment, suggesting dense atmosphere, heavy with the crush of heat and poverty. Houses press close upon one another; scarcely any air moves in the sultry afternoon heat or in her composition. Buildings, Knee seems to say, turn people in upon themselves in isolation. So city dwellers escape outdoors to stroll the sidewalks, gathering in conversational knots on street corners. It is a human-constructed world, crowded with activity. Seen from a high vantage point, walls and rooftops merge into a seemingly solid mosaic of random coloration, punctuated only rarely with a bit of green palm tree or a narrow alley slicing into the maze. The artist suggests spatial recession by lessening details and using a long diagonal of street to bisect the neighborhood, separating foreground from background. Even in the foreground the figures and buildings, though distinct, are largely undifferentiated. Loose brushwork suggests both shimmering heat and the peeling surfaces of deteriorat-

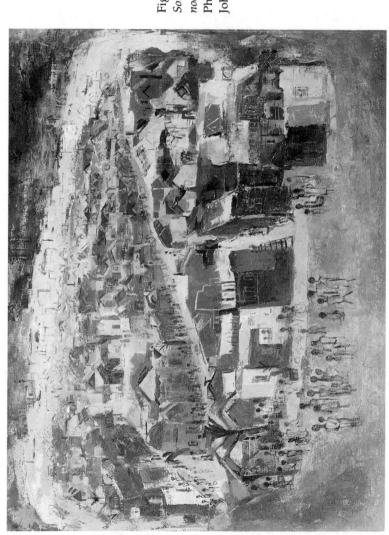

Figure 32. Gina Knee, *A Southern Sunday Afternoon*, 1947, gouache. Photo courtesy Miani Johnson.

ing buildings. But these also display a tightly packed composition of shapes—triangles, squares, rectangles—enlivened by linear accents and abrupt color shifts. As if built of colored wooden blocks, a compactness, an order within disorder, prevails in Houses *on a Hillside* and *A Southern Sunday Afternoon*. In there, too, color and space syncopations create rhythm. To Marian Willard she described the color in the latter painting as "low keyed—greyish blues—and moody feeling colors."[13] Again, it shares some qualities with Mark Tobey's paintings, like his *American Folk Song* (1946), a quasi-figural jumble of rhythmic forms.

At Alex's urging Knee sent *A Southern Sunday Afternoon* along with his own entry to a juried national painting exhibition in New Orleans. Knee's painting was awarded the one thousand-dollar first prize. She was elated. It was the first positive response to her paintings in oil, an indication that she could indeed communicate an aesthetic and an emotive intent to her artist-peers. Suddenly, she had broken through to something vital and genuine, something distinctly her own.

In a torrent of excitement she wrote to Marian Willard. As in the past, once the days of doubt were over she could pour out her jumble of feelings to her most sympathetic friend. Alex, it seemed, had been at the center of her joy and despair, a benign but unrelenting critic. "What a wonderful and difficult person he is!" she wrote Willard: "Being with him makes me paint better but a lot of the time he makes me so nervous and unsure of myself that I ruin a lot of work. I have only recently found out why. I used to go into a kind of trance when I painted, and the results were Ouija board." That is, the results were unpredictable associations of forms and impulses. She feared they often had been merely pretty patterns. What had formerly passed for spontaneity and freely rendered elements from the unconscious now seemed to lack focus and coherence. Listening to her husband's advice, she steeled herself for a more disciplined approach to painting: "Alex has

given me a lot a questions about what I am trying to do and I very often do not have an answer."[14] But she intended to find some answers by listening to his criticism—at least some of it.

She knew that the right path lay somewhere between directionless experiment and mindless fidelity to motif. With Alex, she realized, she had to go her own way, sometimes under the guise of following: "I'm sure that, if I can continue taking [his criticism] I will come out with form and composition and a lot more clarity and not lose the personal spirit." It came down to a painful awareness of her maturation as an artist: "I can't paint as a child paints any longer and growing up is horrible. . . . I have shed more tears and suffered more exhaustion in the last two years than in all the other years of my life."[15]

Tired but exhilarated by the recent breakthrough and the coup at New Orleans, she continued to pour out her feelings to Marian Willard. She knew her dealer/friend would understand her emotional upheavals. Knee explained to her that many paintings were destroyed in the process of excising what Alex declared to be "some other person's work." Five oils out of twenty were judged "completely my own."[16] That small body of work, culled from the larger group, would be the foundation for new explorations in the oil medium.

She stretched out in several directions. First, she began new paintings based on southern life. Some of them, such as *Saturday Again*, continued the theme of figures within a cityscape, but this time much simplified in structure and incident from the complexity of *A Southern Sunday Afternoon*, the New Orleans prizewinner. The new oils were ambitious in size, at least by her standards; *Saturday Again* measured nineteen by twenty-seven inches. She sent it to the big biennial at Richmond, where the jurors recommended it for purchase. From there museum director Daniel Catton Rich requested it for the Art Institute of Chicago's Contemporary American Show. Within two months Knee had received two validations of her new direction.

Her spirits soared along with her reputation. "My oils go very slowly but I love it," she wrote Willard.[17] Each blank canvas presented an arena of possibilities, both in conceptual problem solving and in physical ways of dealing with the canvas. She ventured again into semiabstraction, but with a new firmness and solidity. Every day Knee was learning more about the oil medium. She took pleasure in the manipulation of paint, layering to build dense impasto, changing the direction of brushstrokes to activate the surface, rubbing, blending, incising.

When she repeated a subject it was because she discovered she had more to say about it. It also imposed a certain discipline on her vision to focus repeatedly on the same image. When she worried about "going off in too many separate directions" she would return a second or third time, as many artists do, to a specific motif. This allowed her to mine it more deeply for formal nuances while at the same time attacking the subject with greater abandon.

As her confidence grew she reflected more deeply on her changing artistic credo. To Willard she made a rare statement in writing of her evolving beliefs about the nature of reality, the reality of nature: "I feel that any philosophy natural to me has to be connected with the living and seen as it is—its intangible substance was what I wanted to paint—only it. But now I have come to know that (for me) that 'unknown' in all its lights and shadows is really a part, a skin perhaps, of the forms we see and touch."[18]

Clearly, she felt a new sense of release in accepting the unknown as a component of her work. It afforded her an escape from the tyranny of the perceived image, a return to the wonder and mystery of nature. The canvas is, by definition, a place apart from ordinary reality. When the element of abstraction is added, it becomes that much less mimetic, that much richer in ambiguities. Learning to give visual form to

something that does not yet exist in any physical sense is both the opportunity and the challenge for the abstract artist.

At this point, armed with the unknown as a conscious element, Gina Knee was ready to extend her paintings into the realm of the metaphysical. Cloaking her forms with a "skin" of the unknown was to garb them in mystery. She had long used elements of the unconscious, via Jung and Klee, in her work. But this was something new, something bound up with the very act of applying paint to canvas. It was part of the process, even when she made preparatory drawings.

At home or on long automobile trips with Alex, Knee used sketching for gathering visual information. When he drove to Oklahoma or Florida or Minnesota to fulfill a portrait commission, she would sketch the varied surroundings along the way. From these drawings she excerpted aspects to recombine later in studio paintings.

They spent part of each year in New York, part in Savannah. While in New York, their life centered around the area where Brook and his fellow urban realists had long painted, Washington Square. Here Gina felt herself part of a pulsing nerve center of art, so different from the relatively sleepy environs of Savannah or Santa Fe. It was, after all, his painting and his position in the art world that had first attracted Gina to Alex. Now, in the early years of their marriage, they both savored the mildly bohemian lifestyle he had long known. They rode their tandem bicycle around Greenwich Village and often ate at the Brevoort on Fifth Avenue.

But after a few years they were ready for a more settled existence. Gina was concerned about Alex's drinking, and they both longed for peaceful workspace away from the bustle of the city. In 1948 they purchased a meadowland property at the southern tip of North Haven, just outside Sag Harbor, Long Island. This would become their primary residence for the remaining years of their lives.

The land contained a gracious, weathered old house built in 1804. Standing near the water, Point House had in recent years been occupied by two families and needed renovation. With the help of Brook's son Sandy, Gina and Alex undertook the rehabilitation of the house, modernizing the kitchen and plumbing before they moved in. As they had in Savannah, they also added their own whimsical touches. A Shaker butcher block purchased from a Savannah meat market was brought north as a coffee table. And the area's antiques and second-hand stores yielded what Gina called "wonderful junk." "I've always felt that there was no use doing anything to a house unless it amused you," Alex told an interviewer.[19] He painted a bed with caricatures of himself at work among a bevy of nudes and enlivened doors and woodwork with his painted decorations.

Across an open expanse nearer the road stood a handsome shingled barn, built in 1895, that had once housed horses and carriages. In this airy, high-ceilinged structure the Brooks created two studios, with plenty of space left over for supplies and storage. Here Knee worked on her oils, returning occasionally to gouache and watercolor (figs. 33, 34).

Marian Willard continued to handle Gina's work throughout the decade, but there had been no solo show in New York since 1943. Willard was eager to show Gina's new work and pressed her for an exhibition early in 1949. They assembled six of her oils, including the prizewinning *A Southern Sunday Afternoon* and the abstract *Dream Sequence* (fig. 35). The dozen watercolors were mostly southern themes, with titles like Georgia *Voodoo*, Pigs *in a Forest*, *Yamacraw,* and *Dog Nights*. In making these watercolors, she opened her work again to that quality of the unknown, here manifested in the animism of primeval woodlands. As always, her paintings were a double-sided mirror, reflecting nature and the artist's mood.

The months leading up to the show were difficult. Gina and Alex planned to spend February in Savannah, but the unseasonable cold there drove them farther south, into Florida. "This

Figure 33. Gina Knee in her studio at Point House, Sag Harbor, c. late 1940s. Photo courtesy the *East Hampton Star*.

has been a dreadful month," she wrote Willard, and "the four paintings I sent you are pretty depressing." One of these she called *Moody Idle Waiting*, an apt description of her state of

Figure 34. Gina Knee, *Paper Flowers*, 1949, gouache on paper, 22 x 17 1/4 in.
Photo courtesy Miani Johnson.

mind. On the road to Sarasota she wrote Willard of the despair
she felt:

> We are spending the night at a "Plantation" tour-
> ist camp which features shoddiness and senti-
> mentality—really an old slave place and now at
> sundown long shadows across the quarters and a

Figure 35. Gina Knee, *Dream Sequence*, 1948, oil on canvas, 16 x 20 in. Photo courtesy Miani Johnson.

loud speaker playing tearful songs—I've just had a drink and—oh it is so awful I wish I were dead or in some shining chromium place listening to a lively juke box.[20]

The South, which she had struggled to like as much as Alex did, had become an enervating, oppressive environment for

Gina Knee. She longed for summer at Sag Harbor, for the greater clarity of mind and emotional equilibrium she felt there. She determined to escape to New York for the opening of her Willard Gallery show in late March.

She was plagued by doubts about the new work, fearful that she might be showing it too soon. Was there ever an absolutely right time to exhibit new work? With one foot in the future, one in the past, she felt off-balance, nearly sick with anxiety.

Though she knew that some of the paintings stood at the edge of discovery, approaching something new and meaningful, there were days she saw them as clumsy, crude, trite. Some of the oils looked overworked. Struggling to make the one definitive mark that would bring every other one to rightness, she worked for expression, for spontaneity. She clung stubbornly to the belief that her oils could bring about a fluid exchange between abstraction and realism, between perceptual truth and joyous discovery. But she knew that she didn't always realize these goals in the paintings. The quality of her work was uneven, halting, and she expected critics to fault her for it. She was not far off the mark.

When the show opened reviews were mixed. Most critics found her watercolors "sensitive" or "charming," but they were less taken with the oils. The *Art News* writer put it most bluntly: "The oils are palette-knifed into a stickiness in which there is no feeling of air, sunlight or sky."[21] An *Art Digest* reviewer attributed weakness in the oils to "a tenuous approach to color and form, as well as occasionally drab brushwork."[22] Nonetheless, he liked several of them: *A Southern Sunday Afternoon* and two oils on a new subject, *Evening Trees for Children* and *Child in the Heart of a Woodland*. In these paintings Gina combined her love of landscape with the imaginative faculties she shared with children. With her brush she created a magical tale of secret glades visited by creatures real only in the mind of a child, or of an artist who could retreat to the world

of the imaginary. She remembered a poem she had once written about this imaginary world and sent it now to her friend Spud Johnson in New Mexico:

I thought the sun was made to gild my path
My path to lead me through a wood of rare delights
Nor must I heed
Those other laws that bade me leave
Untouched the flowers
The woods, sweet fruit
And quit my song, and go home mute.

To Johnson, a poet, she apologized for the quality of her verse. It was "not good," she knew, but "very much me."[23] She and Johnson had long been close friends, and she had been the recipient of some of his most personal poetry. They both understood how words and visual images commune with one another, and Gina knew he would welcome her attempts to reclaim in verse her inner life and her past.

The results of the 1949 show trickled in. It would be weeks before she read the complete reviews of her show. She and Alex departed almost immediately after the opening for a month-long trip to fulfill his portrait commissions. On the road she was out of touch, temporarily, with Willard and with the art world in general. It was just as well, for she was certain that the reviews, when published, would be unfavorable. Near the end of the trip she explained her feelings in a letter to Marian: "I really felt that news from you would be so bad that it would make this lovely trip a little less good and since it has been unusually happy for Alex and me—long days traveling together through springtime—I just couldn't let myself in for the emotional effort I would have needed to keep my spirits up if I'd heard from you that my exhibition was a dud." As they approached New York, she felt fortified by the weeks of restorative travel. She was ready to face art-world realities once again, prepared to deal with the adverse critical and com-

mercial outcome of her show: "We can be realistic about everything when I see you—I am feeling fine—I've been sketching daily and in about a week I'll be back in my own studio."[24]

Gina Knee was certainly not the only artist in the late 1940s who felt cut adrift from her art-world moorings. The kind of experimentation she undertook with color, brushwork, and abstraction was paralleled by many other New York artists, whose work received the same kind of scathing response. Adjacent to Knee's April review in the *Art Digest* was one of Mark Rothko, in which the reviewer complained that "these paintings contain no suggestions of form or design. The famous 'pot of paint flung at the canvas' would apply here with a nicety. If there is any lurking significance behind these patternless works, it escapes the observer."[25]

Clearly, many of the New York critics were not prepared for the new streams of painting appearing in their midst. Collectively known as Abstract Expressionism, the New York School, or action painting, the new movement was not a monolithic style. Within it were two mainstreams: color-field painting, exemplified by the innovative work of Rothko, Clyfford Still, and Barnett Newman; and gestural painting, at the center of which were Jackson Pollock, Hans Hofmann, and Willem de Kooning.

The new painting filled the void left by the waning of three other forces in American art: Surrealism, social realism, and Cubist-derived abstraction. At the end of World War II, most of the Surrealist emigrés, in New York to escape the cataclysm on their own shores, returned to Europe. Theirs had been a powerful influence on many American artists, who absorbed from them beliefs in the role of dreams and the unconscious in artmaking, the importance of myth, and the techniques of automatism that released spontaneous visual expressions of the inner self.

The important Sidney Janis catalog of 1944, *Abstract and Surrealist Art in America*, had attempted to define and assess the Surrealists' influence in the United States. (This catalog placed Gina Knee within the Surrealist camp, along with many future Abstract Expressionists: Jackson Pollock, Mark Rothko, Adolph Gottlieb, and William Baziotes.) In that year Jackson Pollock said of the Surrealists-in-exile, "the fact that good European moderns are now here is very important, for they bring with them an understanding of the problems of modern painting. I am particularly impressed with their concept of the source of art being the unconscious."[26] Pollock's own painting would be particularly influenced by André Masson, whose drawings had so impressed Gina Knee in California in 1942.

The Europeans' psychoanalytic orientation was largely Freudian, as established in the work of André Breton. But among the Americans there was more often a Jungian orientation, with emphasis on archetypes and the collective unconscious. Knee had long been a Jungian partisan, as was Jackson Pollock. When they entered psychoanalysis, Pollock in 1939, Knee some years later, each chose a Jungian analyst.

Other influences on the emerging Abstract Expressionists in the late 1940s were the many veins of abstraction. From Cubist-derived geometry and the pure Neoplasticism of Piet Mondrian they moved to considerations of abstract organic forms derived from Picasso, Jean Arp, and Joan Miro. While not forgetting the formal lessons of Cubism, abstract painters in America saw the need for a more subjective art, often using biomorphism, which borrowed vaguely abstract forms from living organisms rather than from geometry.

Common to many painters were powerful cross-fertilizations from myth and the "primitive." Critics saw American Indian, pre-Columbian, early Mediterranean, and other archaic images as affecting the new painting. Gina Knee had been exposed to the intrinsic strength of these forms years be-

fore, during her years in New Mexico and California. Primitive art had long influenced advanced art in Europe. Its recognition in the United States came a bit later but was restimulated by a long series of museum shows on both coasts. Starting in the 1930s American painters were reminded that primitive myths and symbols continue to have meaning in the modern world. At the Museum of Modern Art they saw "African Negro Art" (1935), "Prehistoric Rock Pictures in Europe and Africa" (1937), "Twenty Centuries of Mexican Art" (1940), "Indian Art of the United States" (1941), "Ancestral Sources of Modern Painting" (1941), and "Oceanic Art" (1946). From its formerly marginalized position within ethnographic museums, the art of ancient and tribal cultures entered the mainstream. Everywhere contemporary artists saw examples of the roles played by myth and the collective unconscious in the creation of art.

Gina Knee's 1948 painting *Dream Sequence* (fig. 35) embodies much of this thinking. It is vaguely figural, but its static shapes are pushed nearly to abstraction, ordered like strange, hieratic glyphs. Hovering in different spatial planes, they are not figures in a landscape, as in her southern cityscapes. The figures here represent a symbolic figurative content, rather like (on the left) a costumed iconic dance figure from the Southwest Pueblos or perhaps the primitivizing phase of some latter-day Cubist. But Gina Knee was no Cubist, though she understood its usefulness for deconstructing form and space. Instead, she examined the way color and line contribute to the manipulation of space. The scumbled surface, in places drily brushed, elsewhere incised with a brush handle through thick layers of paint, conveys the rough crudeness she is after. She builds tension between the dense corporeality of the painted shapes—firmed by heavy line and broad brushstrokes—and their ethereal dream origins.

Dream Sequence fulfills Sidney Janis's 1944 prediction of a "merging of abstract and expressionist streams," of a middle ground between Surrealism and abstraction.[27] By 1944 New

139

York artists working in biomorphic abstraction and automatism had come to know one another and had begun to exhibit regularly. In that year, for example, Pollock and Mark Tobey exhibited together in group shows organized by Janis and by dealer Howard Putzel at his new 67 Gallery in New York. Though Mark Tobey's "white writing" paintings were much smaller and more precise than Jackson Pollock's, it is likely that Tobey's all-over painting influenced Pollock's move to that kind of continuous surface.

By this time Gina Knee, who made it her business to see what was new in New York, had also encountered Pollock's work. Tobey's she already knew and admired from their mutual association with Marian Willard. The American art community in the 1940s was really a rather intimate one, and Gina Knee moved easily within it. Her connections on both coasts and participation in large museum shows kept her attuned to emerging developments.

Although she spent long periods in various parts of the country and often experimented with regional subject matter, Knee never became a regionalist as such. Perhaps it was precisely these moves from one area to another that kept her approaches fresh. Hers became an itinerant eye, accustomed to changes in light, topography, and atmosphere, as well as to the raw materials of local myth and legend. When her internal bank of images was depleted, or when she felt lonely and alienated, her resilient imaginative capacity proved her most dependable inner resource. And her desire to integrate the outward substance of painting with an inner subjectivity allied her in the late 1940s with the new trends in painting. With the innovative painters of the New York School she shared the dilemma of composing cohesive pictures while suppressing overt figuration, simplifying drawing and gesture, and maximizing the visual immediacy of color.

Many critics thought it couldn't be done; others continued simply to ignore the radical new painting. A few had a dis-

cerning eye for the gifted new Americans. Chief among these was the influential Clement Greenberg, who wrote art criticism for *Partisan Review* and the *Nation*. Gradually Greenberg's preference for a classic formalist approach was overwhelmed by the raw energy and strength of the Abstract Expressionists. He became their chief exponent and champion. By 1945 Greenberg was hailing Pollock as "the strongest painter of his generation," and a few years later he declared that Americans had eclipsed the French in their innovation: "When one sees . . . how much the level of American art has risen in the last five years . . . then the conclusion forces itself, much to our own surprise, that the main premises of Western art have at last migrated to the United States."[28]

Despite the growing support of critics like Greenberg and the inclusion of Abstract Expressionists in important exhibitions (Arshile Gorky and Robert Motherwell in the 1946 "Fourteen Americans" show at MOMA, for example), general recognition was slow in coming. Most of these artists remained isolated from the mainstream, a condition Greenberg declared essential for their art. The action painters, he wrote, had an "intimate and habitual acquaintance with isolation . . . or rather the alienation that is its cause. . . . [It] is the condition under which the true reality of our age is experienced. And the experience of this true reality is indispensable to any ambitious art." Along with isolation came years of poverty and struggle. The grim reality of life for New York School painters, continued Greenberg, "is the shabby studio on the fifth floor of a cold-water, walk-up tenement on Hudson Street; the frantic scrambling for money; the two or three fellow painters who admire your work; the neurosis of alienation that makes you such a difficult person to get along with."[29]

Gina Knee could claim none of these requisite difficulties. She was spared the grinding poverty, the outspoken critical hostility, the absence of a support system. Her isolation, like that necessary for any creative process, was a self-induced,

psychical one. She needed to retreat consciously from the constant incursions of a strong-minded artist husband who, though generally supportive of her work, could not applaud her increasingly abstract painting. Their financially secure life, filled with friends, provided overt stability and alleviated ordinary loneliness. But at the same time it prevented Gina from experiencing a true sense of community with like-minded artists. She struggled to reach out, to find an affirmation of her art, to assume momentarily the dizzy, breathtaking stance of the artist-rebel.

She immersed herself in the torrent of advanced painting beginning to flood New York museums and galleries, some of which spilled over into the sleepy environs of Long Island. When Knee and Brook settled at North Haven in 1948, many other artists of all stylistic persuasions already were living in the area. At the Springs, East Hampton, were Jackson Pollock and Lee Krasner, both at the center of Abstract Expressionism. The volatile, doom-haunted Pollock, long plagued by alcoholism, stopped drinking from 1948 to 1950 and entered the period of his most remarkable productivity. These were the years of his unprecedented "drip" paintings, great skeins of luminous color dripped onto large canvases on the floor. Using automatism to unleash a new kind of creative energy—one that emphasized process over product—Pollock's paintings were a sharp break with the past. Their reverberations would soon be felt throughout the art world.

His wife, Lee Krasner, was making significant abstract paintings in those years as well. Having studied with Hans Hofmann, she was considered by many of her friends to be more talented than Pollock when they met. But she was so engulfed in her husband's creative explosion that she soon withdrew to a subsidiary status to promote him. "I was not the average woman married to the average painter," she recalled; "I was married to Jackson Pollock. The context is bigger and even if I was not personally dominated by Pollock, the whole

art world was."[30] Eventually, her own work began to seem "irrelevant."

Krasner's contributions to early Abstract Expressionism thus were submerged beneath those of her husband. For nearly forty years her accomplishments went largely unrecognized, a fate common to most women associated with the New York art world in the 1940s. It was a male-dominated, market-oriented art community—this despite the important positions held by women dealers such as Peggy Guggenheim and Betty Parsons, whose power in the art market far exceeded that of Marian Willard. Those women dealers largely were uninterested in the work of women painters. Even Pollock's support of his wife's painting was not enough to give her recognition in the late forties; at his insistence Parsons gave Krasner a solo show but dropped her when Pollock left the gallery.

Krasner's colleagues Alice Neel and Louise Bourgeois, who also emerged in the 1940s, suffered similarly at the hands of artists, dealers, and critics. They too remained nearly invisible in the art world for some three decades. Only with the advent of a second generation of Abstract Expressionist painters did the fortunes of women improve: Helen Frankenthaler, Elaine de Kooning, and Grace Hartigan managed to find the recognition that had eluded many women of Gina Knee's generation. Even then, however, a romantic alliance with an artist, dealer, or critic often was the initial key to career success, like it or not.

In the fall of 1948 a number of artists met in the Springs to plan an exhibit of their work at the East Hampton Guild Hall. Pollock's notes from that meeting—a list of names on a page filled with his doodles—have been preserved and reproduced in the *catalogue raisonné* of his work.[31] The list of artists was begun by painter John Little, who wrote "Gina Knee" as the first name and then turned the list over to Pollock for completion.[32] Pollock wrote "Knee" again later in the list; thus her name appears twice amid those of fourteen other painters, mostly abstract, on the Little-Pollock list. By the time of the

exhibition, however, the composition of the group had changed considerably. On July 7, 1949, "Seventeen Artists of Eastern Long Island" opened, but with only five of the painters from Pollock's preliminary list. Instead, the exhibition was weighted in favor of realist painters, including Alexander Brook. Gina Knee remained in the show, as did Pollock and Krasner, but Motherwell, de Kooning, and others chose not to exhibit.

The tone of the East Hampton show differed considerably from the abstractionists' original conception, but it still proved controversial. It was, according to the museum's curator, Helen Harrison, the occasion on which the Guild Hall audience was introduced to the "modernist insurgents." As participant and planner, Gina Knee contributed to the path-breaking show; "she was among the prime movers," added Harrison, "in our taking note of the avant-garde trends."[33]

During the next four decades Gina Knee would take part in eight more Guild Hall exhibitions—some solo shows, some group exhibitions. She conceived the idea for a highly successful show in which well-known Long Island artists were asked to show one of their paintings alongside one from their collection by, if possible, an artist who had influenced them.

Despite her exhibitions with the Abstract Expressionists and her affinity for their roots in Surrealism, myth, and abstraction, she remained on the margins of the movement. Like the other women surrounding the group, Knee was never integrated into its power structure. Even had they been invited, one wonders how many of these women would have committed to the stern and solitary self-consciousness of the action painters—an attitude that lingers, depending on one's point of view, either as powerful moral example or unmitigated arrogance. Regardless, their attitudes were seldom those inculcated in women of Gina Knee's generation. Taught to be social, forgiving, flexible, they usually lacked the bravado of their male counterparts. Consider Pollock's famous existential

contention "I am nature"; here is an assertion utterly foreign to Gina Knee's belief that the artist undergoes what she termed a "primary experience" before nature. Hers was a certain humility before nature, his a Promethean challenge to nature.

It was also a question of theatricality: Critic Harold Rosenberg spoke of the Abstract Expressionist canvas as "an arena in which to act—rather than . . . a space in which to reproduce, re-design, analyze or 'express' an object actual or imagined."[34] That kind of heroic, larger-than-life existential act of painting required a kind of reckless abandon, an unrestrained freedom, a will to defy art's rootedness in tradition. To sweep aside memory, association, and reflexive identity from painting was more than Gina Knee was prepared to do. With Robert Motherwell, whose work she admired, she continued deliberately to synthesize diverse ideas from twentieth-century art into her own painting, maintaining a sometimes unfashionable historical and social consciousness.

Like some of the gesture painters she retained suggestions of nature in her abstract art, utilizing semifigurative motifs and vaguely illusionist space (all anathema to the purist color-field painters). But even as she exhibited with Pollock (and later with de Kooning) their ways diverged. She understood what the action painters were up to and appreciated their rethinking of the creative process, but she could not see the need for the bombast surrounding their godlike self-presentations.

Not least of the obstacles between Gina Knee and the Abstract Expressionists was the antipathy fomenting in the studio adjoining hers. Alex, whose own work was being eclipsed by the explosive Abstract Expressionists, "intensely disliked what they were doing and would not associate with them," recalls a close friend. Another friend was painter Buffie Johnson, whose name also appeared in Pollock's planning notes and who often exhibited with Gina Knee in the Guild Hall shows. During a sixteen-year period in Sag Harbor, Johnson saw Gina often and observed, "Her husband did everything to keep her

from her work. Although they loved each other they disagreed a great deal."[35]

"Alex had a fierce temper," notes another friend, "and Gina feared it, and did everything she could to keep the peace." At times, she needed every ounce of acting ability she could muster—not for making grand gestures on the arena of the canvas, but merely for disguising her true feelings. "She was so totally bound to Alex's side," concludes this friend, "that she did not, in his presence, express thoughts or opinions which she knew would irritate him."[36]

Quietly, obsessively, she fought to keep her art alive and on track. The creative will exerted nearly constant pressure, though sometimes it was driven underground by conflict at home. For periods of time she gave up painting when the demands of family and household required it. Though it frustrated her not to work in the studio, sometimes weeks went by without her crossing the field to enter it. Then, awakened by a breakaway visit to the city or stimulating art talk with an old friend, she would return with renewed diligence to her work. After a visit to Marian Willard, she wrote to thank her friend for providing more than mere hospitality: "I came back to a new day and so free in my spirit that it was as if I'd suddenly recovered from an illness—I've been working nearly every day since . . . and I think that some of [the paintings] have come alive—they should because I have."[37]

Gina's capacity for deep, lasting friendships carried her through many dark periods. When her relationship with Alex turned especially stormy, she often confided in Marian Willard, her friend Patricia Coughlan, or Eloise Spaeth. Spaeth—author, art collector, patron and organizer—had many opportunities to observe the Knee-Brook relationship. "As the years went on she really *suffered* under him," mused Spaeth, citing as an example the occasion in 1952 when she invited Gina ("a genius at installing an exhibition") to accompany her to Venice for the installation of the prestigious Venice Biennale. Gina ac-

cepted with pleasure and withdrew the funds for the trip from her personal bank account, requesting that Alex be allowed to think that her expenses would be paid by Eloise Spaeth. Brook would "have a tantrum," Gina knew, if he thought she was spending money "so foolishly"—even though it was her own.[38] The trip was a revelation for Gina. Together she and Eloise Spaeth installed the Edward Hopper room at the Biennale, then departed on a joyous pilgrimage to see some of the masterpieces of European art. Open to the inventiveness of any period, Gina was particularly engaged by the Giottos in Italy, the Matisse chapel in Vence, France, and the great Spanish masters at the Prado.

She continued to exhibit, sometimes with other abstractionists, sometimes in invitational shows of a more general makeup. In 1950 ten East Hampton abstractionists were shown at the Guild Hall; Pollock, Krasner, Motherwell, James Brooks and Buffie Johnson joined Gina Knee that year. In 1953 the Guild Hall show "Seventeen East Hampton Artists" featured four artist couples: Gina Knee and Alexander Brook, Gertrude and Balcomb Greene, Elaine and Willem de Kooning, and Lee Krasner and Jackson Pollock.

By this time the fortunes of the Abstract Expressionists had improved significantly. Heady with the confidence that their work challenged and often surpassed the best coming out of Europe, they began to take themselves more seriously. They were the rising stars of the New York art world and had come to believe that their work would be of lasting historical significance.

The formerly loose affiliation of Abstraction Expressionists began to dissolve as the big names among them entered the canon of modern painting. The easy camaraderie of equality gave way to intrigue, fired by jealousy or suspicion of one another's success. Artists who showed at Betty Parsons and at the Kootz Gallery began to close ranks, often selecting only among themselves for the shows they organized. They im-

posed policies of restriction on their activities and publications—informal at first, but calculated to exclude artists of lesser reputation. Underway were processes that would enshrine some painters, push others to the margins, and drop still others into oblivion.

Those enshrined almost exclusively were men, and the New York School became an increasingly male enclave. Painters Paul Brach and Miriam Schapiro recall that no women were present at board meetings or policy discussions of the Club and the Eighth Street Club. And at the Cedar Bar, one of their major meeting places, Lee Krasner felt that women were "treated like cattle."[39] She remembered Barnett Newman's remark to her, "We don't need dames."[40]

Nobody seemed to see the inconsistency when only one woman, Hedda Sterne, was included in the famous photograph of the "Irascible Eighteen" who protested in 1951 against exclusionary exhibition policies at the Metropolitan Museum of Art. Participation in events such as a three-day Abstract Expressionism conference at Studio 35 in 1950 and the 1951 show Motherwell organized, entitled "The School of New York," was by invitation only. Again, only one woman was included in the catalog of this definitive show.

Gina Knee's connection with the group had been tenuous from the start, and its increasing elitism left her on the periphery of things. The scale, subtlety, and occasional reticence of her paintings still lacked the evidence of cathartic and tragic struggle seen in Pollock, de Kooning, or Motherwell. Knee's upbringing had taught her to contain her tragedies and joys, not to exhibit them for public viewing.

And, despite her frequent forays into abstraction, she preferred to maintain ties to visual reality. Often she used recognizable imagery, usually landscape elements, as a springboard from here to there. Knee knew she had found her personal idiom in the context of landscape, broadly construed. Having absorbed elements from many artists in her formative years

(like most painters, including the Abstract Expressionists), she was secure enough with her own evolved style to resist an empty eclecticism. She would remain sympathetic to the action painters, but from a distance. While they were personalizing the universe she would continue quietly to preserve the experience of the personal.

During the 1950s and 1960s Gina continued to exhibit with the Long Island Abstract Expressionists in regional exhibitions like those at the Guild Hall. While these became her main exhibition forum, the Abstract Expressionists' major interest and livelihood was now centered elsewhere. With the death of Pollock in a violent automobile crash at the Springs in 1956, the art scene on Long Island shifted into a different gear. Pollock had been the most visible link to the artistic avant garde, the figure who defied Ad Reinhardt's condemnation of Long Islanders as "East Hampton aesthetes."

Reinhardt's dismissal notwithstanding, many distinguished artists, including good abstract painters, remained in the area. The lists of participants in the regional shows where Knee exhibited during the 1950s encompassed many of the important figures in American art. Fairfield Porter, Jacques Lipchitz, Conrad Marca-Relli, Joan Mitchell, Larry Rivers, Paul Brach, Moses and Raphael Soyer, Balcomb and Gertrude Greene, John Graham, and Ilya Bolotowsky all showed at the Guild Hall in East Hampton.

Many, like the Soyers, David Burliuk, Julian Levi, and Niles Spencer, were personal friends who visited the Brooks at home. Artist and writer friends from New Mexico also came to Point House: Howard Cook and Barbara Latham, Ward and Clyde Lockwood. Living a few miles away on Long Island was Gina's dear friend from the Santa Fe days, playwright Lynn Riggs. All reminded her of the indelible impact of the Southwest on her life. When Riggs died in 1954, Gina wrote to a friend, "New Mexico dies in little pieces—and each time the whole lives again." [41]

149

Memories survived through sustained friendships, but also through art. Gina and Alex filled the rooms of Point House with paintings, prints, and sculpture of the artists they admired, all arranged by Gina with an eye to informal harmonies of color and design. Pre-Columbian objects and Indian artifacts from the Southwest recalled Knee's former existence, while examples of the Brooks' own work and the memorabilia of two lives in art added to the pleasing jumble of objects. The spaces were comfortable and intimate, warmed often with the laughter of friends. Gina still enjoyed cooking and invited guests to join her in the spacious, friendly kitchen as she prepared meals (fig. 36).

Despite the outward display of harmony, life with Alex was complicated by his steadily increasing irascibility. At times Gina felt hopelessly oppressed by her husband's unshakable opinions, fierce temper, and domineering manner. Inwardly she seethed at the subservient role he silently assigned her, and at times she exhausted her store of the saintly forebearance and attentiveness required of the mythic "wife-who-also-paints." At those moments her anger bubbled to the surface. On the day of her tenth anniversary with Brook she mused to her friend Patricia Coughlan that she had spent ten years with Goodlow Macdowell, ten years with Ernest Knee, and now had completed ten years with Brook. She wondered aloud whether, given the turbulence of their marriage, she should stay with Alex or whether she would be better off alone. Her decision to remain with him was based, at least in part, on the grim prospect of growing older alone. "I can't stand the idea," she confessed to Patricia Coughlan, "of being an old lonely woman in a dining room."[42]

Instead, she sought refuge in her studio—refuge from Alex's storms and from the pressures of the New York art scene. To a friend she wrote, "The world of art is so confusing I'd like to forget it exists and just give myself to an isolated creative world bounded by my studio walls—alas, it is very

Figure 36. Gina Knee in her kitchen at Point House, Sag Harbor. Photographer unknown. Photo courtesy Photography Collection, Harry Ransom Humanities Research Center, University of Texas at Austin.

hard to do."[43] She could never isolate herself completely, but she could find solace in work.

In her studio the same energies that combatted despair gave rise to a steady flow of new paintings. In 1955 Marian Willard assembled a show of works by three women painters: Gina Knee, Dorothy Dehner, and Sibley Smith. Each showed eight

watercolors. Knee's were mostly of subjects inspired by her travels with Brook to the Pacific Northwest in the summer of 1954 and to Spain the previous year. Her color choices were sensitive to locale: those of the Northwest Coast, like *Rocks and Inlet* and Oregon *Coast*, were predominantly blue-green and gray, while Spain, as in *Castile in August*, called for a sunnier palette of yellows, salmon, and pale bottle greens. Critics pointed out, with approval that managed to sound a little condescending, a romantic subjectivity in the work of all three painters. The old, familiar feminine terminology was dragged out: sensitive, delicate, tender, intuitive, lyrical (the latter a word Helen Frankenthaler has denounced as particularly "loaded"). But there is no evidence that Knee objected to any of these words as discriminatory. Most likely she would have found the appellations pleasing, for she was trying to express the inner quality of her experience at a particular time and place. The test for her was to fix an impression shaped by her own sensibility, not someone else's expectations.

For Gina, the trips that inspired these paintings eased the built-up tensions of life at Sag Harbor. Away from the New York art world there were good times with Alex—times when their creative energies flowed in parallel channels, times when their diverse sensibilities resonated with similar emotions. It amused them to compare their individual responses to the same visual stimuli. They had enjoyed long automobile trips during their early years together. Now they began to plan longer sojourns, sometimes leasing their house to tenants for months at a time.

There were repeated trips, starting in the late 1940s, to Spain. During the next two decades they visited various parts of the country, once on an extended stay of fifteen months during 1953–54. They traveled widely in the Iberian peninsula, but Barcelona and its environs was a favorite locale. In her usual sensitive way, Knee grasped the essential character of the Spanish landscape. The ancient villages of the Pyrenees,

with their Romanesque churches and stepped walls, re-minded her of her beloved New Mexico. Little concerned with incursions of Western-style "progress," the Basque and Catalan towns had changed slowly over the centuries. They, like her images of them, owe very little to the discernible exigencies of a day or a month.

On later trips she made etchings, occasionally hand colored with the prevailing ochres and browns of the Spanish earth (fig. 37). Some are spare, ascetic, with large expanses of white void; others are crowded with incident, layered with the rich density of hatching and washes. These recall the airless intensity of the Georgia towns she painted in the mid-forties, now translated into a Spanish idiom. The Spanish watercolors, drawings, and etchings are small, intimate, exploring the mysteries of light and shadow, emptiness and plenitude (plate 9). Their scale suggests at first the possibility of a single exposure or reading. The viewer might even stop looking and go away, but when the eye returns it begins to explore the work with a conscious mobility, led from one area to another by a path that the artist has prepared for it. It is often a complex one, an Ariadne's thread into the labyrinthine spaces traced by the etcher's needle.

Knee's Spanish oils and gouaches were larger, bolder, with dark tonalities and weighted colors. Obscured shapes and densely worked passages convey some of the elegiac quality of Robert Motherwell's Spanish canvases. For Gina Knee, however, they are a reprise of colors and atmosphere she had known in the American Southwest (*Caldera*, plate 10). Often during these years she referred to the lingering influence of New Mexico in her work, as when she provided a note to accompany her *Evening in Castile* in a Guild Hall traveling exhibition. Writing in the third person, she said of herself:

> Although she now lives in Sag Harbor, Gina Knee
> is a painter of the warm images of New Mexico

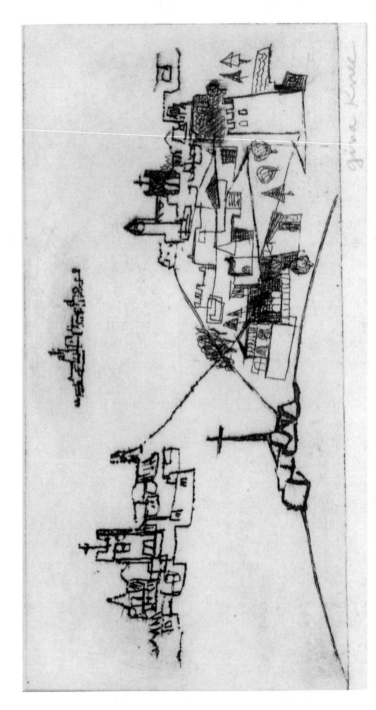

Figure 37. Gina Knee, *Untitled [Spanish Village]*, etching, 4 x 7 1/2 in. Photo courtesy Cynthia Rogers and Lou Garbus.

and the Southwest. The first 15 years of her painting career were spent in that area, and it is in those forms and coloration that she is happiest. The aura of the early evening, when the heat is gone and the air cools is subtly portrayed in this oil painting.[44]

In 1963 her five paintings in the East Hampton Guild Hall show were all oils, three of them favorites from the visits to Spain. More subtle than *Evening in Castile* is *Misty Town*, a painting of translucency, fog, and vagueness, of tiny incidents pullulating softly in a large field. More than anything else, Knee was trying to recreate objective correlatives of favorite remembered scenes. Her statement accompanying the show is wistful, succinct, even a little nostalgic:

> Painting has been a necessary part of my life for nearly thirty years and [it] still seems to be the natural and most pleasant way of reliving my personal intimacies with things and places. When invention or distortions or symbolic shapes appear in my work, I hope they suggest the essence or meaning of the original experience.[45]

All her formal devices, she seems to be saying, are there to render more acutely the abiding sensation.

Favorable reviews greeted these Spanish paintings, but as important were the personal notes and letters from people moved by the paintings. They reinforced Gina's confidence that her art communicated experience to those beyond herself. And despite her occasional desire to isolate herself with her work, her natural affinity for people drew her back to the circle of friends and family.

She especially enjoyed having children about. Her step-grandchildren visited occasionally, but more often it was the children of friends and neighbors who brought youthful exuberance to the Brook house. As had happened in Santa Fe,

Gina developed special relationships with children and shared her talents with them. Cynthia Rogers, daughter of Gina's close friend Patricia Coughlan, recalls that as a child she learned to make etchings under Gina's direction. This was during the 1960s when Knee had begun to work a good deal with graphic media. She had materials and an etching press in her studio and often made prints based on her trips to Spain. At that stage of her life Gina was not always patient with children, recalls Rogers, but she enjoyed doing things for them, like making costumes for holidays and school plays. In images painted during those years she occasionally freed her imagination to follow the freshness and whimsy of a child's (plate 11).

Knee also took a lively interest in the art life of the community, often helping with exhibits at area museums. Once she organized a show at the local library called "Artistic Pastimes of Sag Harbor Villagers." The rule was that you could exhibit only what you did for fun, not what you did for a living. This eliminated professional artists such as the Brooks, but it gave Gina great pleasure to encourage the artistic pursuits of her friends and neighbors. There was always a bit of the teacher in her.

Out of that show of amateur art grew a friendship with one of the exhibitors, Charles Balth. A retired carpenter, the eighty-seven-year-old Balth entered a small plaster sculpture of a fantastic animal. Knee liked to recall that when she saw it she remarked, "I believe you could be a folk artist," to which he replied, "What's a folk artist?"[46] They became fast friends, and with her usual generosity of spirit she began to promote his work. Soon his sculptures were being exhibited in galleries and shops from New York to California.

Her own exhibitions during the 1960s and 1970s were sporadic. She was chosen for the first large survey exhibition of painting in New Mexico, assembled by Van Deren Coke in 1963. The show's venues in Albuquerque and Fort Worth, and

particularly the book published with the exhibition, did much to draw public attention to the long and varied history of painting in New Mexico. Coke noted Knee's contributions as modernist painter and group organizer during her years in New Mexico.[47]

She also was chosen for one of the early exhibitions surveying the history of American women in art. "Women Artists of America 1707–1964" opened April 2, 1965, at the Newark Museum with the work of 129 painters and sculptors. Curator William H. Gerdts expressed the show's multiple intentions of resuscitating long-forgotten reputations, presenting overlooked artists from the recent past, and demonstrating the breadth and diversity among contemporary American women painters and sculptors. It was gratifying for Knee to be included among the 129 artists chosen to represent the entire history of women in American art. If she had worked in an earlier generation she might well have languished in complete obscurity. Lacking sympathetic dealers and exhibition opportunities, generations of women had been lost to the history of American art. Relegated to attics, junkpiles, and incinerators were the paintings and sculpture of women whose reputations were never born, whose achievements went unrecognized. Knee's opportunities, though often thwarted by circumstances, far exceeded those of many women working in the arts. And her achievements, however modest, had at least placed her within the ranks of working professionals. For the Newark show Gerdts chose Knee's painting *Winter Valley*, an oil rich with the colors of dormant earth in which living seeds lie waiting beneath a blanket of snow.

The same year, at the age of seventy-five, she was given her only true retrospective show. Sponsored by Skidmore College and the Larcada Gallery in New York, the exhibition was a selection of paintings from the 1930s through the 1960s. Reproduced in the color brochure were an early watercolor, *Near Pittsburgh*, 1935 (plate 2), and a late oil, *Spanish Images*, 1965

(plate 12). But most prominent of the three color reproductions was a detail from her 1943 watercolor *Near Cordova, New Mexico* (plate 6), one of the most successful of her glowing Southwestern landscapes. In the retrospective statement she looked back over four decades of painting her world. She recalled the various locations in which she worked—New Mexico, Georgia, Spain, the Northwest Coast—and the impression each had made on her development. Even after an absence of nearly thirty years, she realized that it was the Southwest that had spoken most clearly to her artistic sensibility. "The color and memory-shapes and feelings of New Mexico never went away," she wrote.[48] And despite her incisive, highly personal interpretations of other landscapes, real and imaginary, it was the Southwestern ones she chose to represent her work; the Skidmore show was made up largely of watercolors from her years in New Mexico.

In 1965 Alexander Brook stopped painting, declaring that he had ceased growing as an artist and had begun to repeat himself. When he saw that he couldn't paint any better than he had before, he decided to retire.[49] But he kept busy with his love for tools and materials, collecting, fixing, and tinkering in the studio.

As her eightieth birthday approached, Gina remained active and alert. "She was never old, only older," recalled a close friend.[50] But then Alex's health failed, and Gina threw herself into caring for him. During his last illness she proved a devoted nurse. Once, when he fell, she gathered her own diminished strength to lift his much larger bulk back into bed.

Alex died in 1980; after his death, according to friends, Gina was never the same again. She missed the daily give-and-take with the gruff, demanding, often endearing man who had been her husband for thirty-five years. Days were empty without their daily laughter, their frequent bickering. As is often the case with people who have lived together for a long time, daily friction had given bite and piquancy to their lives.

Without it, life held far less interest for Knee, and she sharply curtailed her activities.

Only an occasional exhibition at a Long Island or Manhattan gallery roused her attention. Friends and family visited, but they could see her strength and will to live ebbing visibly. Only two weeks before her death Gina's last exhibition opened, appropriately, in Santa Fe. Twenty-five watercolors from her years in the Southwest were shown, after which the family donated them to the Museum of Fine Arts. Gina Knee died at a Suffolk, New York, hospital on her eighty-fourth birthday, October 31, 1982.

Notes

1. Alexander Brook, "Young America: Peggy Bacon," *Arts* (Jan. 1923): 68.

2. Peggy Bacon, from a 1979 interview in the *Maine Sunday Telegram*, quoted in Roberta K. Tarbell, "Peggy Bacon's Pastel and Charcoal Caricature Portraits," *Woman's Art Journal* 9, no. 2 (Fall–Winter 1988–89): 36. For a substantiating view of Brook's effect on Bacon's career, see Karen A. Bearor, "Peggy Bacon 1895–1987," in *American Women Artists: The 20th Century*, ed. Elsa Honig Fine (Knoxville: Knoxville Museum of Art, 1989), 5.

3. Patricia Coughlan, personal communication, 18 June 1988.

4. Gina Knee to Elizabeth Shepley Sergeant, 16 Apr. 1944, Sergeant Papers, Yale Collection of American Literature, Beinecke Library, Yale University, hereafter cited as YCAL. Alexander Brook had a brief marriage after his divorce from Peggy Bacon.

5. Wylly Folk St. John, "Artists at Home in a Cotton Warehouse," *Atlanta Journal Magazine*, n.d., Alexander Brook Papers, Archives of American Art, Smithsonian Institution.

6. Gina Knee to Spud Johnson, n.d. [c. 1950], Johnson Papers.

7. Gina Knee to Henriette Harris, n.d. [c. 1945], Johnson Papers.

8. Ibid.

9. Gina Knee to Marian Willard, 6 Feb. 1948, WGP.

10. Gina Knee to Marian Willard, 12 Jan. 1946, WGP.

11. Gina Knee to Marian Willard, 27 Jan. 1947, WGP.

12. Artist's statement, *Gina Knee Retrospective Exhibition* (New York: Skidmore College), 1973, n.p.

13. Gina Knee to Marian Willard, n.d. [1948], WGP.

14. Gina Knee to Marian Willard, 6 Feb. 1948, WGP.

15. Ibid.

16. Ibid.

17. Gina Knee to Marian Willard, n.d. [1948], WGP.

18. Gina Knee to Marian Willard, n.d. [spring 1948], WGP.

19. Alexander Brook, quoted in Jack Graves, "The Star Talks to the Brooks, of Point House," *East Hampton Star,* 19 May 1977.

20. Gina Knee to Marian Willard, 8 Mar. 1949, WGP.

21. "Gina Knee," review, *Art News* 48 (Apr. 1949): n.p.

22. "Gina Knee: Sensitive Impressions and Imaginings," review, *Art Digest* (15 Apr. 1949): 27.

23. Gina Knee to Spud Johnson, n.d. [contextually, late 1940s], Johnson Papers.

24. Gina Knee to Marian Willard, 26 Apr. 1949, WGP.

25. "Mark Rothko at Parsons," *Art Digest* (15 Apr. 1949), 27.

26 Jackson Pollock, answers to a questionnaire, *Arts and Architecture*, LXI, no. 2 (Feb. 1944): 14.

27. Sidney Janis, quoted in Irving Sandler, *The Triumph of American Painting* (New York: Harper & Row, 1970), 80.

28. Clement Greenberg, "Art Chronicle: The Decline of Cubism," *Partisan Review* XV, no. 3 (Mar. 1948): 369.

29. Clement Greenberg, "Art Chronicle: The Situation at the Moment," *Partisan Review*, XV, no. 1 (Jan. 1948): 82–83. The Abstract Expressionists were not totally isolated; they created a sense of community with their protest activities, their short-lived school "The Subjects of the Artist," the "Eighth Street Club," and the Cedar Bar.

30. Lee Krasner, quoted in Roberta Brandes Gratz, "Daily Close-Up—After Pollock," *New York Post*, 6 Dec. 1973.

31. See Francis V. O'Connor and Eugene V. Thaw, eds., *Jackson Pollock: A Catalogue Raisonné of Paintings, Drawings, and Other Works*, vol. 3, *Drawings, 1930–1956* (New Haven and London: Yale University Press, 1978), catalog no. 779.

32. Josephine Little, personal communication, 23 June 1993. Little recalls hearing the account of this list-making "many times" from her late husband, John Little, and the Pollocks. Josephine Little believes that some confusion surrounds the date of this note. There were, in fact, at least two East Hampton Guild Hall shows of seventeen artists. The first, titled "Seventeen Artists of Eastern Long Island," was held in July 1949; another, called "Seventeen East Hampton Artists," opened in the summer of 1953. Between the two came "Ten East Hampton Abstractionists" at the Guild Hall in 1950.

33. Helen A. Harrison to author, 3 Nov. 1987.

34. Harold Rosenberg, *The Tradition of the New* (Chicago and London: University of Chicago Press, 1982), 25.

35. Buffie Johnson to author, 25 Jul. 1992.

36. Eloise Spaeth, personal communication, 12 May 1988.

37. Gina Knee to Marian Willard, n.d. [early 1950s], WGP.

38. Eloise Spaeth and Enez Whipple to author, 12 May 1988. Spaeth was chairman of the traveling exhibitions program for the American Federation of Arts and was in charge of the American Pavilion at the Biennale.

39. See Whitney Chadwick, *Women, Art and Society* (London: Thames & Hudson, 1990), 304.

40. Lee Krasner, quoted in Ellen G. Landau, "Tough Choices: Becoming a Woman Artist, 1900–1970," in *Making Their Mark: Women Artists Move into the Mainstream, 1970–85* (New York: Abbeville Press, 1989), 35.

41. Gina Knee to Elizabeth Shepley Sergeant, 30 June 1954, Sergeant Papers, YCAL.

42. Patricia Coughlan to author, 27 Aug. 1989.

43. Gina Knee to Elizabeth Shepley Sergeant, 13 Mar. 1960, Sergeant Papers, YCAL.

44. Gina Knee, artist's statement, *Artists of the Region: A Guild Hall Traveling Exhibition*, Dec. 1975, n.p.

45. Gina Knee, catalog statement, *Painting/Sculpture by Artists of the Region*, Guild Hall, East Hampton, New York, 18 Aug.– 2 Sept. 1963, n.p.

46. Gina Knee, quoted in "A Unique Team Breeds a Happy Menagerie," *Island Courier*, n.d. [c. 1979], 3.

47. Van Deren Coke, *Taos and Santa Fe: The Artist's Environment 1882–1942* (Albuquerque: University of New Mexico Press, 1963), 72, 75.

48. Artist's statement, *Gina Knee Retrospective Exhibition*, n.p.

49. Graves, "The Star Talks."

50. Patricia Coughlan to author, 27 Aug. 1989.

CONCLUSION

Questions remain about Gina Knee, especially about her place in American art. Why, we ask ourselves, has she been almost forgotten? In the decade since her death, and in the four decades since Abstract Expressionism's heyday, much has changed in the art world. Nothing less than a scholarly revolution has taken place—a revolution that has challenged the paradigm of art history as a sequence of styles that vanquish and supersede one another. This "psychosexual model of heroic patricide," in the words of Norma Broude and Mary Garrard, has crumbled, taking with it some of art history's traditional goals and priorities.[1]

Absent the controlling mystique of an innovative avant garde, all kinds of art-world hierarchies have begun to break down as well. We are free to ask new kinds of questions: about the cherished myths of modernism, about alternative readings of art based on different historical models, about the paralyzing fear artists face of being branded derivative. Specifically, we can ask how the traditional gender roles assigned women have affected their perceptions, experience, and expectations of the world. How can art made by a woman illuminate the person as a whole?

In the early days of feminist iconographical analysis, critics saw something intrinsically feminine in the canvases of women painters. Their overall surfaces, decentered imagery, fragmentary perception, and lack of strict hierarchical ordering were thought defining characteristics of a feminine aesthetic. (All could, at times, be isolated in the work of Gina Knee.) But more recently scholars and critics have turned the spotlight on the cultural construction of knowledge. They ask how "ideas about such things as giftedness, status, masculinity and femininity, good and bad art get formed and embedded."[2] This broader approach has seemed most appropriate to answering the question posed above: Why has Gina Knee (with countless other women painters) been nearly forgotten?

The notion of socially constructed experience relates to larger questions of power in society. In the art world, who controlled access to exhibitions, publications, and museums? Power in the art world, as Randy Rosen writes, operates both formally and informally:

> Anyone can have an opinion abut art, but even at the informal level some opinions exert more authority than others. Because our society isolates art as a specialized activity, its explanation and validation have come to reside outside of intuitive "I like it, I don't like it" judgments, resting instead with art specialists: artists, curators, critics, collectors, museum directors and trustees, art historians, and art dealers. Happenstance coalitions and shifting allegiances within this network of "validators" shape and reshape the mainstream.[3]

To work outside the mainstream has been an almost certain guarantee of oblivion for artists. The consensus that places an artist within the mainstream always eluded Gina Knee; at times, especially through her associations with the nascent

"art stars" of Abstract Expressionism, she seemed about to break through. But she remained, frustratingly, bafflingly, on its margins. Why? I would argue that a combination of circumstances, both societal and personal, worked to maintain Knee's marginalization.

She never learned how to manipulate the complex corridors of access to the mainstream; that is clear from the preceding chapters. The point here is not to argue for a politics of victimization. Redress is not to be found in the whine of a postmodernist rhetoric that would replace the overwhelmingly male canon with a revisionist pantheon, precisely composed according to gender, race, and class. The authority of the past remains, for better or worse. It is something that can both inspire and intimidate the artist. In 1951 Robert Motherwell wrote, "Every intelligent painter carries the whole culture of modern painting in his head. It is his real subject, of which everything he paints is both an homage and a critique, and everything he says a gloss."[4] And more recently, Robert Hughes concurs: "All writers or artists carry in their mind an invisible tribunal of the dead. . . [that] sits in judgment on their work. They intuit their standards from it."[5] Ultimately, it is this connectedness artists feel to the past that integrates them into the timeless stretch of creativity.

Gina Knee's standards were derived from her attention to some of the most accomplished painters of her day. From John Marin, and more directly from her teacher Ward Lockwood, she learned to abstract from nature, transforming its essences into bold color marks on paper. These she organized with precision, like definitive words in a line of poetry, making the marks carry their own formal impulse.

In later paintings, those linked to Knee's involvement with Paul Klee's aesthetics, tonal blendings and atmospheric softness encourage associations with dream and memory. From Klee she learned to invest her paintings with the authority and authenticity of the imagination. She selected and arranged

forms of subtle inevitability, shapes that emerge from and represent a zone preceding language. Organic, limpid, they shimmer with a new born fluidity.

Fluid too is the structure of her paintings—a structure that owes more to the loom than to the skeleton. Knee's mature paintings, firm yet flexible, are woven with skeins of liquid color. The resulting web gently anchors her loose, painterly technique. Against such a floating color matrix, like recurrent flickers of emergent thread, her small strokes pick out patterns. One can almost enter their textures, so haptic is the surface. That Knee's marks also represent trees, furrows, houses, or animals seems almost gratuitous. Yes, they are poetic signifiers. But mostly these paintings are about color—especially about its power to evoke mood and reverie—and about organic change in nature.

How important to her was the "primary experience" before nature? I suggest that it was central to her whole conception of art and self. As we have seen, metaphors of growth, flow, and change are everywhere in her painting. They work to reconnect human life with the natural cycle of nonhuman life, erasing rigid boundaries and placing all life on a dynamic, nonhierarchical continuum. She placed herself on that seamless expanse as well, as a being who is part of the universe with a creative role to play in it.

In her reverence for myth, Knee gives attention to the ways in which our present draws on the energies of the ancient past. Resurrecting mythic motifs from other art and from her imagination, she denied supremacy to the temporal moment. To paint with absolute fidelity to a slice of observed reality was, she came to realize, as absurd as trying to live solely in the present, without memory; both presuppose an ability to close off competing perceptions. Instead of reducing her perceptual field, Knee chose to embrace the wider, deeper spaces of the natural and the mythic world. And, in doing that, she mythologized the natural world as home. Gaston Bachelard has

called this spatial inclusiveness, this expanded field of perceptual at-home-ness, spaces of "intimate immensity."[6]

But another kind of power must be taken into account—the complex structures of power within a woman's most personal relationships. Patricia Meyer Spacks has asked probing questions about women's power and creativity. She writes, "The puzzle of how power relates to love in a woman's experience is central to the dilemma of the woman as artist." This is especially true with a woman like Gina Knee, whose search for love challenged (and, I would argue, often defeated) her need to make art. Adds Spacks, "The conflict between the yearning for artistic expression and the desire for relationship, is not peculiar to women, but women are likely to experience it with special intensity."[7]

But why should these needs conflict, one wonders, when a woman is married to two men who were themselves artmakers? The answer, I believe, lies in the power structures that develop within relationships—the way each partner views his or her relative power and how that power affects both love and professional achievement. "Some women," writes Spacks, "imagine that accomplishment is one more means to love; some fear that it is love's enemy. Almost all seem to understand that publicly acknowledged achievement is a mode of power."[8] Gina Knee wanted both recognition and love, that rare attainment noted by Balzac: "To be celebrated and to be loved, that is happiness!"

She also came to understand that, particularly in her marriage to Alexander Brook, accomplishment could indeed became love's enemy. A wife's rising reputation can be a threat to a partner whose ego requires that he be the recognized artist in the family. What if his career wanes even as his wife approaches the spotlight? The result could be disastrous: conflict, anger, perhaps even separation. And separation was what Gina Knee feared most; her decision to remain with Alex rather than face a lonely old age was an act of compromise, an

acknowledgment of defeat in the marital power struggle. Her aspirations for artistic success had been too unfocused to compete with the clear alternative of abandonment.

Must we then count Gina Knee's experience as among the failures of women to make it in the art world? If by success we understand personal acclaim, recognized genius, and mainstream status, then Gina Knee's and most women's stories are narratives of failure. If, however, we look at alternative yardsticks, her life in art yielded a rich harvest. Through art she reconciled the outer world with the inner. Her painting allowed her the freedom to be both receptive and active, to explore the intimate and autonomous, to face what she feared, and to struggle, however imperfectly, to reconcile the elusive balance of love and work in her life. In the end, her art redeemed every bargain she ever made; it gave meaning to a fragmented life.

Notes

1. Norma Broude and Mary D. Garrard, eds., *Feminism and Art History: Questioning the Litany* (New York: Harper & Row, 1982), 15.

2. Randy Rosen, "Moving into the Mainstream," in *Making Their Mark: Women Artists Move into the Mainstream 1970–1985* (New York: Abbeville, 1989), 19.

3. Ibid, 9.

4. Robert Motherwell, *The School of New York*, (Beverly Hills: Perls Gallery, 1951), n.p.

5. Robert Hughes, "The Fraying of America," *Time* 139, no. 5 (3 Feb. 1992): 47.

6. See Gaston Bachelard, *The Poetics of Space* (New York: Beacon, 1969), 183–210, 245.

7. Patricia Meyer Spacks, *The Female Imagination* (New York: Avon, 1975), 206, 213.

8. Ibid., 206.

SELECTED BIBLIOGRAPHY

American Art Annual. Washington: The American Federation of the Arts, vols. 31 (1934), 32 (1935), 33 (1936), 34 (1937–8).

Andrews, Martin R., ed. and comp. *History of Marietta and Washington County and Representative Citizens.* Chicago: Biographical Publishing Company, 1902.

Archives of American Art, Smithsonian Institution, Washington, D. C. Papers of Ward Lockwood, Willard Gallery, Alexander Brook.

Bachelard, Gaston. *The Poetics of Space.* New York: Beacon, 1969.

Beinecke Library, Yale University. Papers of Mabel Dodge Luhan, Elizabeth Shepley Sergeant.

Benson, E. M. *John Marin: The Man and His Work.* Washington: American Federation of Arts, 1935.

Clark, Kenneth. *Civilisation.* New York: Harper & Row, 1969.

Coke, Van Deren. *Marin in New Mexico / 1929 & 1930.* Albuquerque: University of New Mexico Art Museum, 1968.

——. *Photography in New Mexico: From the Daguerreotype to the Present.* Albuquerque: University of New Mexico Press, 1979.

——. *Taos and Santa Fe: The Artist's Environment 1882–1942.* Albuquerque: University of New Mexico Press, 1963.

Eldredge, Charles. *Ward Lockwood.* Lawrence: University of Kansas Museum of Art, 1974.

Eldredge, Charles, Julie Schimmel, and William Truettner. *Art in New Mexico 1900–1945: Paths to Taos and Santa Fe.* Washington: National Museum of American Art and Abbeville Press, 1986.

Fine, Ruth E. *John Marin.* Washington: National Gallery of Art and Abbeville Press, 1990.

Harry Ransom Humanities Research Center, University of Texas at Austin. Papers of Walter Willard "Spud" Johnson.

Heilbrun, Carolyn G. *Writing a Woman's Life.* New York: Norton, 1988.

Homer, William Innes. *Alfred Stieglitz and the American Avant-Garde.* Boston: New York Graphic Society, 1977.

Hunter, Sam. *B. J. O. Nordfeldt: An American Expressionist.* Pipersville, Pa.: Richard Stuart Gallery, 1984.

Janis, Sidney. *Abstract and Surrealist Art in America.* New York: Reynal & Hitchcock, 1944.

Jonson Gallery Archives, University of New Mexico. Papers of Raymond Jonson.

Kennedy Galleries. *John Marin's Mountains.* New York: Kennedy Galleries, 1983.

Making Their Mark: Women Artists Move into the Mainstream 1970–1985. New York: Abbeville, 1989.

Knee, Gina. *Monkey in the Mirror: A Satirical Comedy in One Act.* New York: Samuel French, 1939.

Levin, Gail, and Marianne Lorenz, eds. *Theme and Improvisation: Kandinsky and the American Avant-Garde 1912–1950.* Boston: Little Brown, 1992.

Museum of Fine Arts, Museum of New Mexico, Santa Fe. Exhibition brochures for annual exhibitions of painters and sculptors of the Southwest, 1933–36, 1938–42.

Nin, Anaïs. *The Diary of Anaïs Nin,* vol. 2, 1934–39. New York: Harcourt, Brace & World, Inc., 1967.

O'Connor, Francis V., and Eugene V. Thaw, eds. *Jackson Pollock: A Catalogue Raisonné,* 4 vols. New Haven: Yale University Press, 1978.

Reich, Sheldon. *John Marin: A Stylistic Analysis and Catalogue Raisonné.* Tucson: University of Arizona Press, 1970.

Riggs, Lynn. *Russet Mantle and The Cherokee Night: Two Plays by Lynn Riggs*. New York: Samuel French, 1936.

Rio Grande Painters. Santa Fe: Rydal Press, n.d. [c. 1933].

Rosenberg, Harold. *The Tradition of the New*. Chicago: University of Chicago Press, 1982.

Rubinstein, Charlotte S. *American Women Artists*. New York: Avon, 1982.

Rudnick, Lois P. *Mabel Dodge Luhan: New Woman, New Worlds*. Albuquerque: University of New Mexico Press, 1984.

Sandler, Irving. *The Triumph of American Painting*. New York: Harper & Row, 1970.

Spacks, Patricia Meyer. *The Female Imagination*. New York: Avon, 1975.

Tufts, Eleanor. *American Women Artists, Past and Present*. New York: Garland, 1984.

Van Wagner, Judy K. C. *Women Shaping Art: Profiles of Power*. New York: Praeger, 1984.

Weigle, Marta, and Kyle Fiore. *Santa Fe and Taos: The Writer's Era 1916–1941*. Santa Fe: Ancient City Press, 1982.

Women Artists of America 1707–1964. Newark, N.J.: Newark Museum, 1965.

INDEX

M

N

O

P

Q

R

Rauh, Ida, 26
Ray, Man, 81, 107
Redon, Odilon, 108
Reinhardt, Ad, 149
Renoir, Jean, 81
Rich, Daniel Catton, 128
Riggs, Lynn, 149
Rio Grande Painters, 33, 35
Rivers, Larry, 149
Rocks and Inlet, 152
Rogers, Cynthia, 156
Rosen, Randy, 164
Rosenberg, Harold, 145
Rothko, Mark, 137
Rudnick, Lois Palken, 7

S

Sacramento, California, 121
Sag Harbor, 130, 135, 145, 152 - 153
Santa Fe, 17, 19, 21, 24, 26 - 27, 31,
 33, 44, 46, 75, 77 - 78, 84, 159
Santo Domingo, New Mexico, 13
Saturday Again, 128
Savannah, Georgia, 117, 121 - 123 -
 125, 130
Schapiro, Miriam, 148
Schnaufer, Ellen Baxter, 4
Schnaufer, Virginia, 4
Schnaufer, William T., 4
Seed and Roots, 104
Seed Pods Never Die, 103
Sheets, Millard, 95
Showalter, Elaine, 3
Shuster, Will, 16
Siesta, 56, 75
Sloan, John, 16, 21, 51
Smith, David, 67, 95
Smith, Sibley, 151
Snowbound, 62, 64 - 66, 75 - 76

Southern Sunday Afternoon, A, 125,
 127 - 128, 131, 135
Soyer, Moses and Raphael, 149
Spacks, Patricia Meyer, 7 , 167
Spaeth, Eloise, 146 - 147
Spain, 152
Spanish Images, 157
Spencer, Niles, 149
Sterne, Hedda, 148
Stieglitz, Alfred, 11, 47, 107
Still, Clifford, 137
Stockton, Anne, 33
Storm at Otowi, 44
Strand, Paul, 47
Summer Landscape, Taos, N.M., 12
Sun, Wind and Stars, 34
Surrealism, 67
Swallows Return to Capistrano, 106
Swallows Returning to Capistrano, 35
Synesthesia, 80 - 81

T

Taos, New Mexico, 6, 13, 17, 25 -
 26, 75
Taylor, Nancy Thompson, 46
Tesuque, 27, 56, 62, 78, 122
Tesuque studio, 46
Tesuque Spring Apple Trees, 28
Tobey, Mark, 68, 121, 127, 140
tourism, 24
tourists, 21
Transcendental Painting Group, 45
Tree Sounds, 81
Tucson, 17

V

Valley of the Gods, 109
Van Cleave, E. Boyd, 33
Venice Biennale, 146

W

Y

Z

The color reproductions of Gina Knee's paintings
in this publication were made possible
through the generous support of Sallie Bingham.